THE
BLACK COUNTRY ALBUM
50 YEARS OF EVENTS, PEOPLE & PLACES

GRAHAM GOUGH

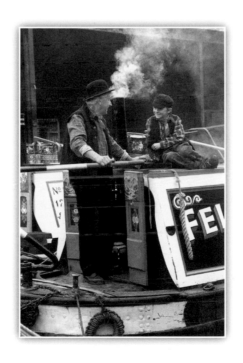

The
History
Press

To Mary for her constant help and patience.

ACKNOWLEDGEMENTS

Adrian Faber, Editor, *Express & Star*
Dudley Archives, in particular Jane Humphrey
Mark Andrews, Chief Feature Writer, *Express & Star*, for his
 help with picture research and dates
James Windle, journalist and friend, for his valuable
 advice

PICTURE CREDITS

Express & Star
Mirrorpix
Photograph of Graham Gough, bottom of page 5,
 James Mander

First published 2012

The History Press
The Mill, Brimscombe Port
Stroud, Gloucestershire, GL5 2QG
www.thehistorypress.co.uk

© Graham Gough, 2012

British Library Cataloguing in Publication Data.
A catalogue record for this book is available from the British Library.

ISBN 978 0 7524 7974 3

Typesetting and origination by The History Press
Printed in Great Britain

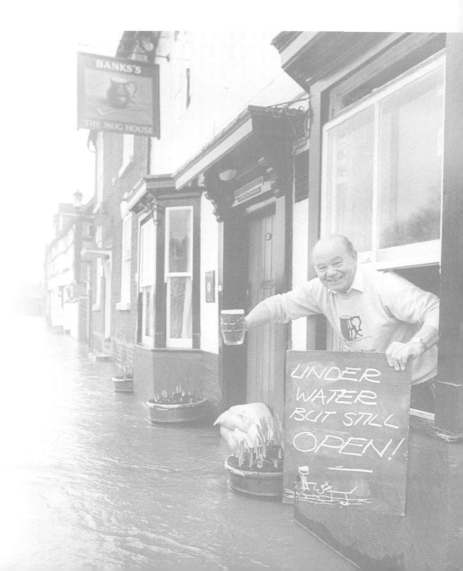

CONTENTS

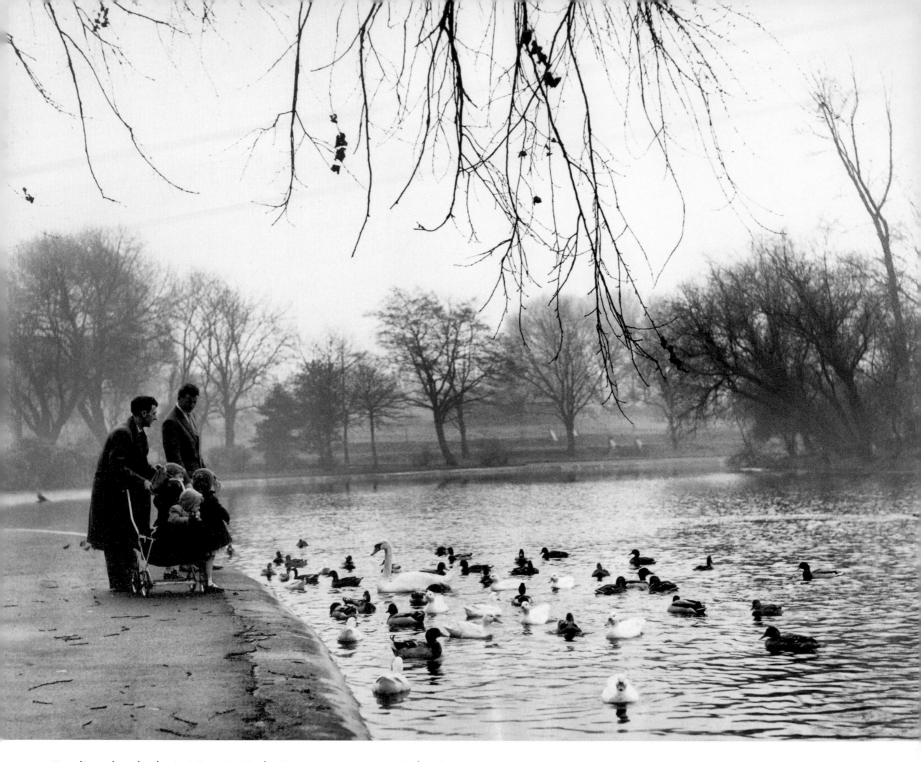

Feeding the ducks in Victoria Park, Tipton, on a winter's day in 1958.

ABOUT THE AUTHOR

O n an autumn morning in 1954 I walked into a newspaper office for my first day of work and from that day on I have been captivated by the world of newspapers and press photography. After a six-month trial I was taken on as a trainee photographer with the Dudley Herald Series and indentured for five years. Within twelve months I was photographing the Duke of Bedford and taking tea with him at Woburn Abbey and I thought to myself – this is the life for me! Unfortunately though, news photography is not all tea and cakes.

During the early days I covered the royal visits of Her Majesty the Queen and Princess Margaret; the funeral of footballer Duncan Edwards who died in the Munich air disaster; Hillman's leather works fire and the murder of the eighty-seven-year-old Jewish moneylender Louis Cassell. But the biggest news story of them all was the Dudley Riots which made national news for a week in August 1962.

In the 1960s I left Dudley and moved to Devon, joining the Devonshire Press in Torquay and then the Daily Mirror Group in the South West. During my time in the West Country I covered a wide range of assignments, from film and TV stars to the *Pacific Glory* oil tanker disaster in Lyme Bay and the Royal Review of the Home Fleet in Torbay, spending three days on the aircraft carrier HMS *Eagle* and going aboard the Royal Yacht *Britannia*.

Then in the 1970s I returned to my home ground and joined the *Express & Star* in the West Midlands. During my time there I won the Midland News Picture of the Year Award in 1975 and 1976. The picture in 1975 of male stripper Andy Wade was published worldwide and artist Beryl Cook based her painting 'Ladies Night' on the photograph. In Her Majesty the Queen's Silver Jubilee year, 1977, I won the National Royal Picture of the Year Award with a shot of Princess Alexandra stuck in farmyard muck at the Three Counties Show, Malvern, and in 1983 won the Midlands Press Photographer of the Year Special Award and the Best Balanced Picture in the same competition in 1993.

In 2000 I left the *Express & Star* and concentrated mainly on landscape photography for the tourist industry and to promote Britain at home and abroad. My photographs are also used to illustrate books and magazines. In spring 2011 I held an exhibition of my pictures at Himley Hall and they are currently displayed at Dudley Archives.

When I started taking pictures in the late 1950s I used a 5 x 4 glass plate press camera and for most of my career rushing back to darkrooms was a major part of the job. Now it's the latest in digital photography and press cameramen can sit in their cars and send images to picture desks from a laptop. The world of photography has changed dramatically since my early days, but having a keen eye for a picture will never change.

Graham Gough, Kinver, 2012

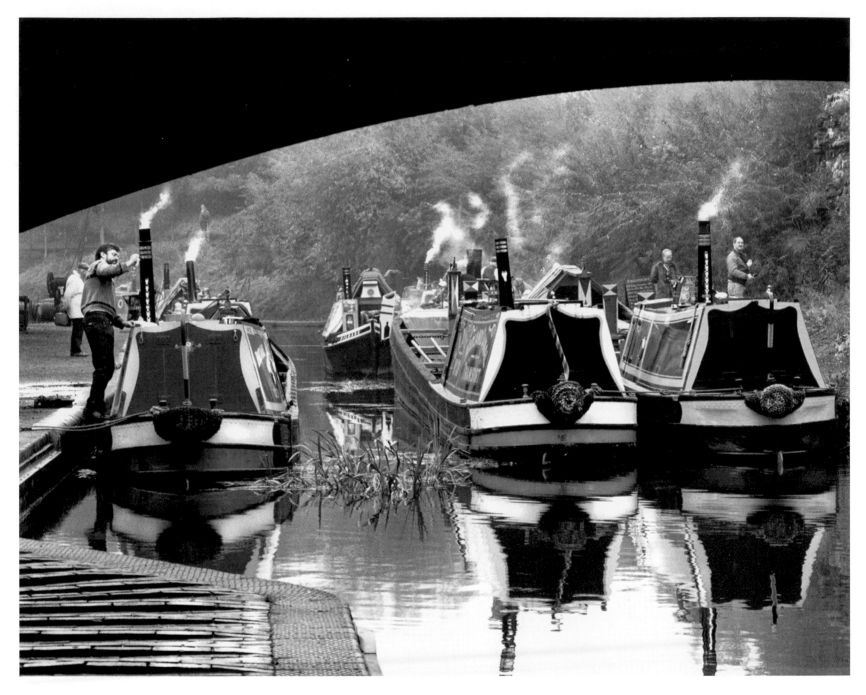

Narrowboats getting up steam during a boaters' weekend at the Black Country Living Museum.

NEWS

Riots, fires, floods and strippers – all in a day's work for a press photographer. From extreme weather to fighting in the streets and a train that crashed through the same wall twice to a man living in a cricket pavilion, these are just a few of my pictures which made local, national and international news.

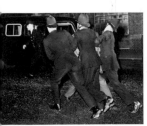
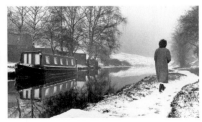
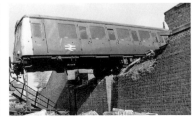
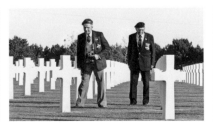
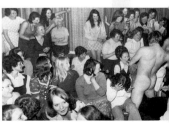

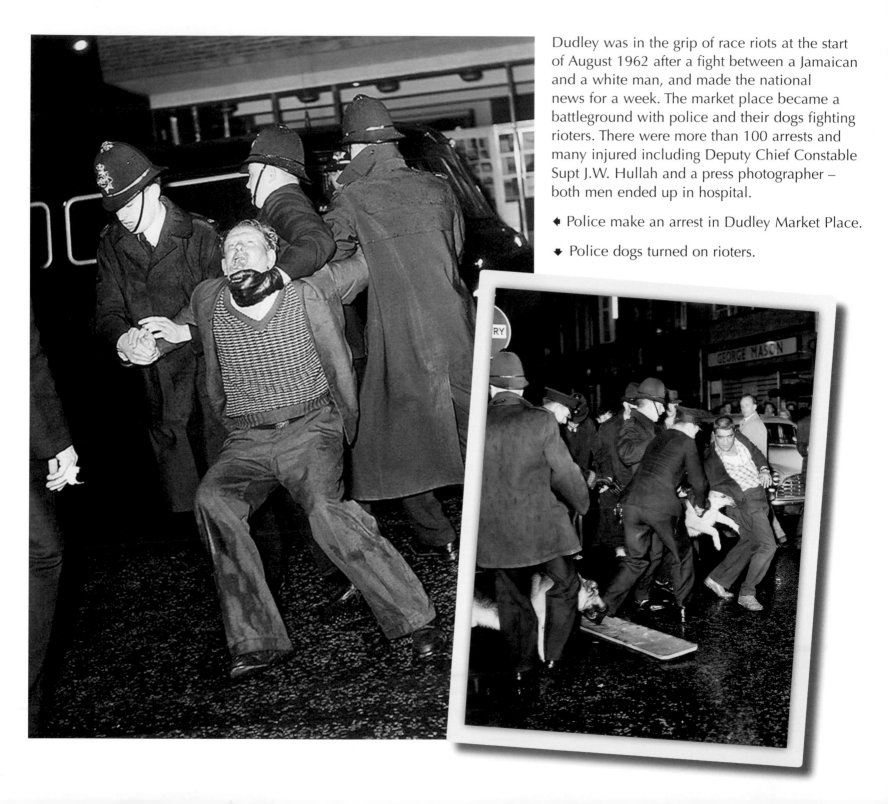

Dudley was in the grip of race riots at the start of August 1962 after a fight between a Jamaican and a white man, and made the national news for a week. The market place became a battleground with police and their dogs fighting rioters. There were more than 100 arrests and many injured including Deputy Chief Constable Supt J.W. Hullah and a press photographer – both men ended up in hospital.

◀ Police make an arrest in Dudley Market Place.

▼ Police dogs turned on rioters.

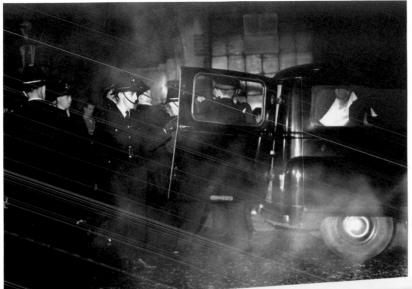

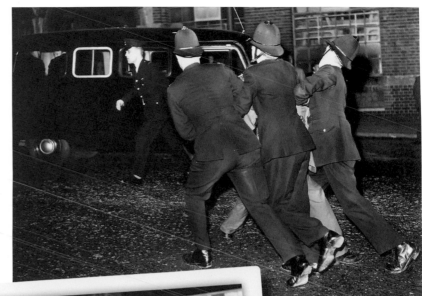

♠ Police bundle
a man into a
Black Maria.

♠ A struggling
youth destined for
police cells.

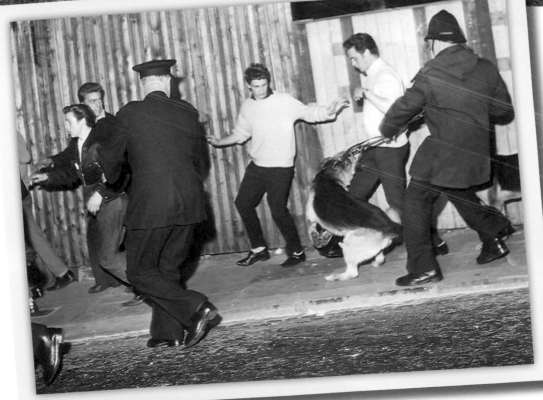

♦ Youths are kept
in check by police
dogs.

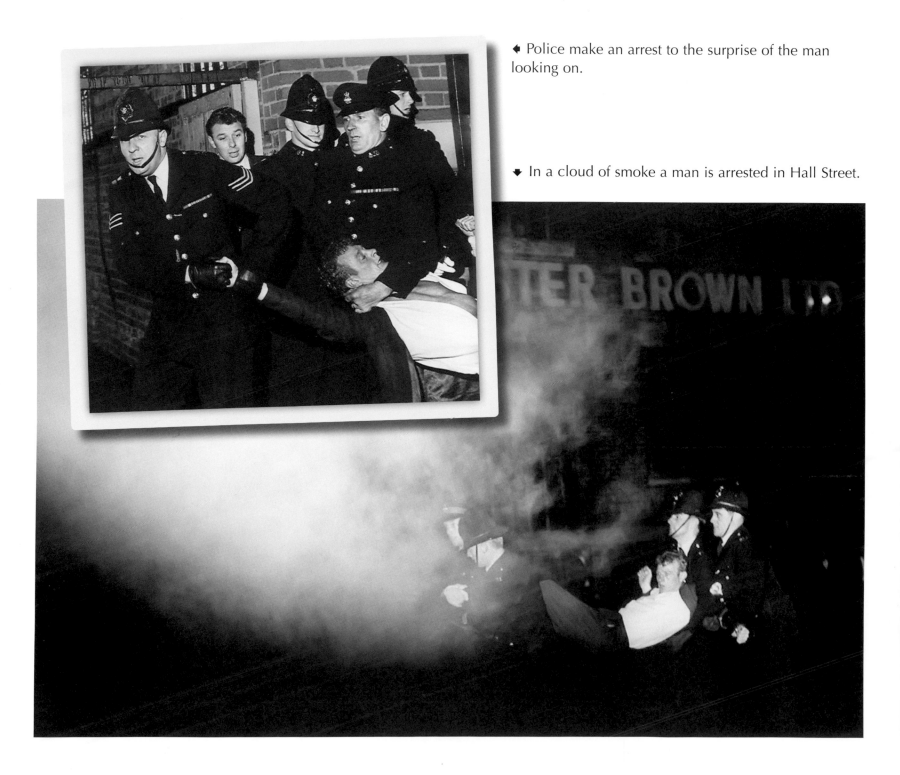

◆ Police make an arrest to the surprise of the man looking on.

◆ In a cloud of smoke a man is arrested in Hall Street.

➧ Police patrol North Street as a black resident and children stand in the doorway of a house which had been damaged by rioters.

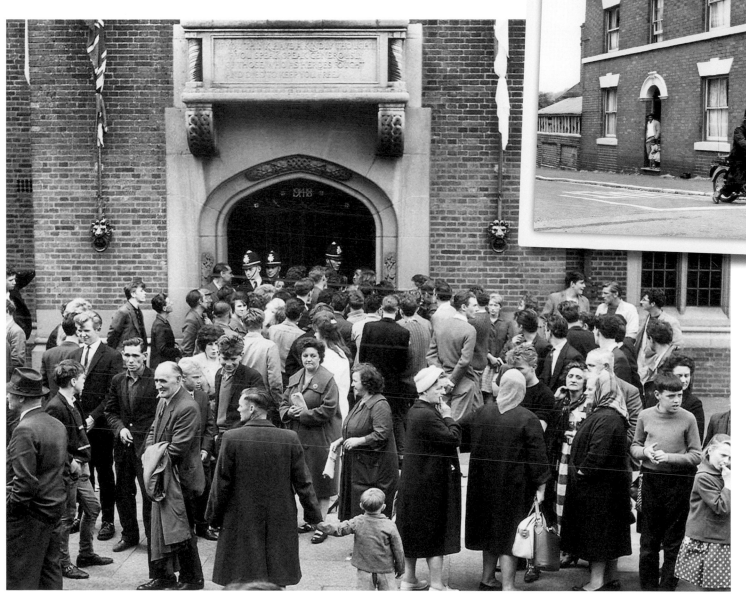

◀ During the Dudley Riots, this was the regular daily scene outside the magistrates court.

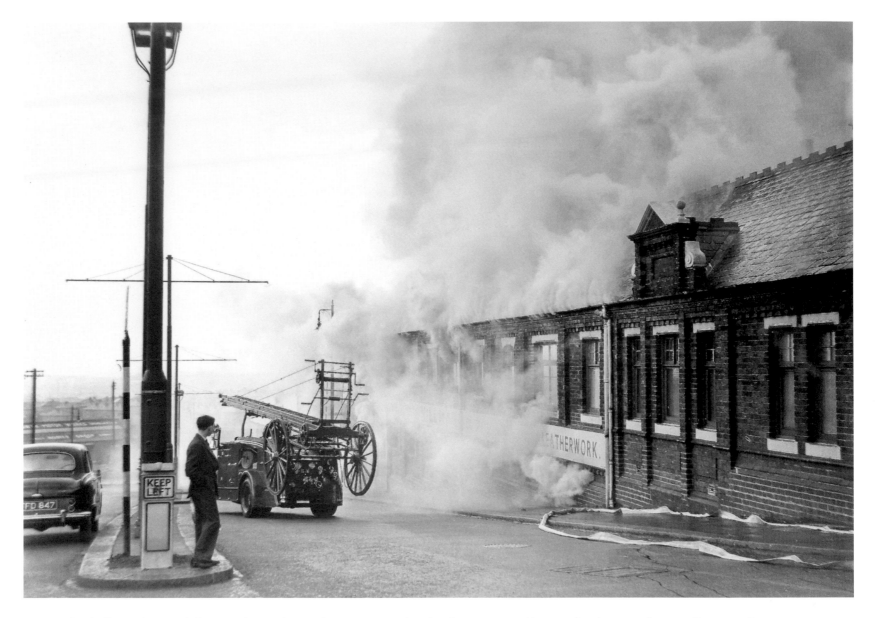

➤ Smoke billowed out of the machine shop when a major fire broke out at Hillman's leather works, Dudley, April 1958. Note the wheeled fire engine ladder.

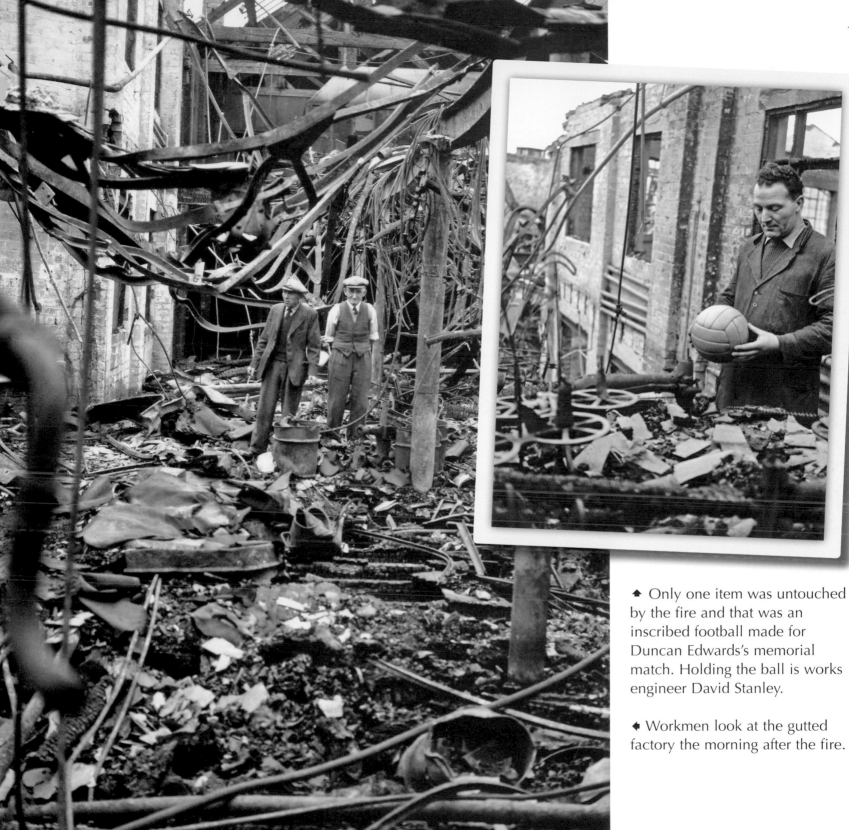

◆ Only one item was untouched by the fire and that was an inscribed football made for Duncan Edwards's memorial match. Holding the ball is works engineer David Stanley.

◆ Workmen look at the gutted factory the morning after the fire.

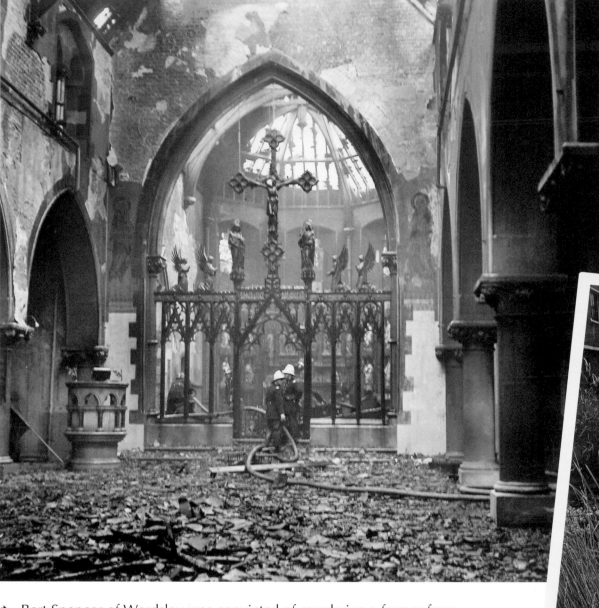

◆ Church fires are rare but in 1964 St Michael and All Angels, Caldmore, Walsall, was completely destroyed. It was rebuilt in 1967.

◆ Bert Spencer of Wordsley was convicted of murdering a farmer from Prestwood near Stourbridge and was an inmate of HMP Wayland, Norfolk. He had won an award for the best-kept prison garden and reporter Tony Bishop and myself were given a very rare opportunity to interview him and take pictures while he was at work in the garden.

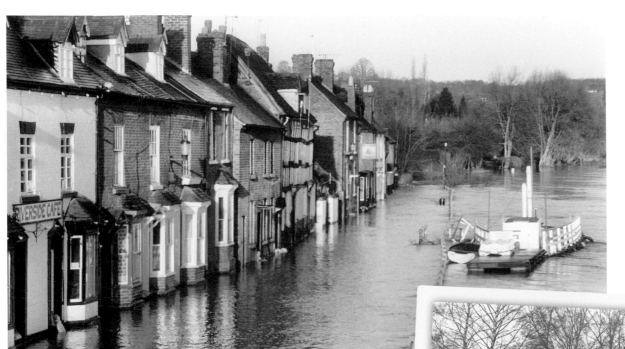

◆ The River Severn flooding at Bewdley with the old Arley ferry adrift. Flooding was common here until new flood defences were put up in 2004.

◆ Snow on 2 May 1979 – it was the coldest recorded May night for ninety years. This rare shot of spring looking like mid-winter was taken along the canal at Kinver.

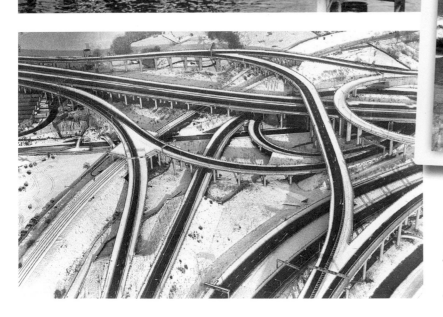

◆ Frozen Spaghetti. This was rush hour at Spaghetti Junction in January 1979 after 50 miles of the M6 had been closed and the M42 shut. This picture was taken from an open-sided helicopter and I was strapped in as the aircraft banked so that I could angle my shot.

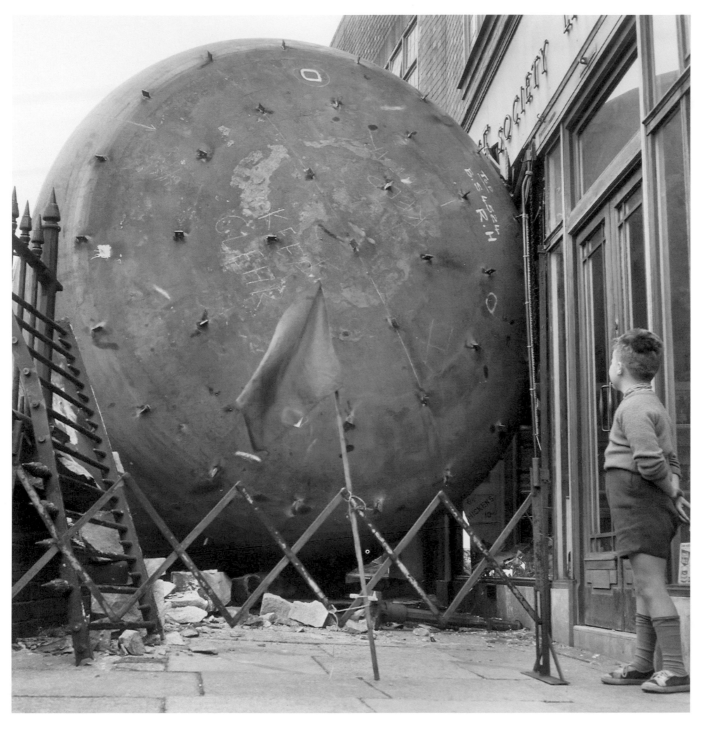

◆ This giant boiler fell from the back of a lorry and blocked Owen Street, Tipton, in 1959. Thankfully no one was injured.

◆ The Stourbridge Dodger hangs over Foster Street after failing to stop at Stourbridge Town station in April 1977. Out of twenty passengers on board, nine were injured.

◆ Yet again the Dodger hits the wall of Stourbridge Town station, this time in March 1990. Note the sign on the right of the photograph.

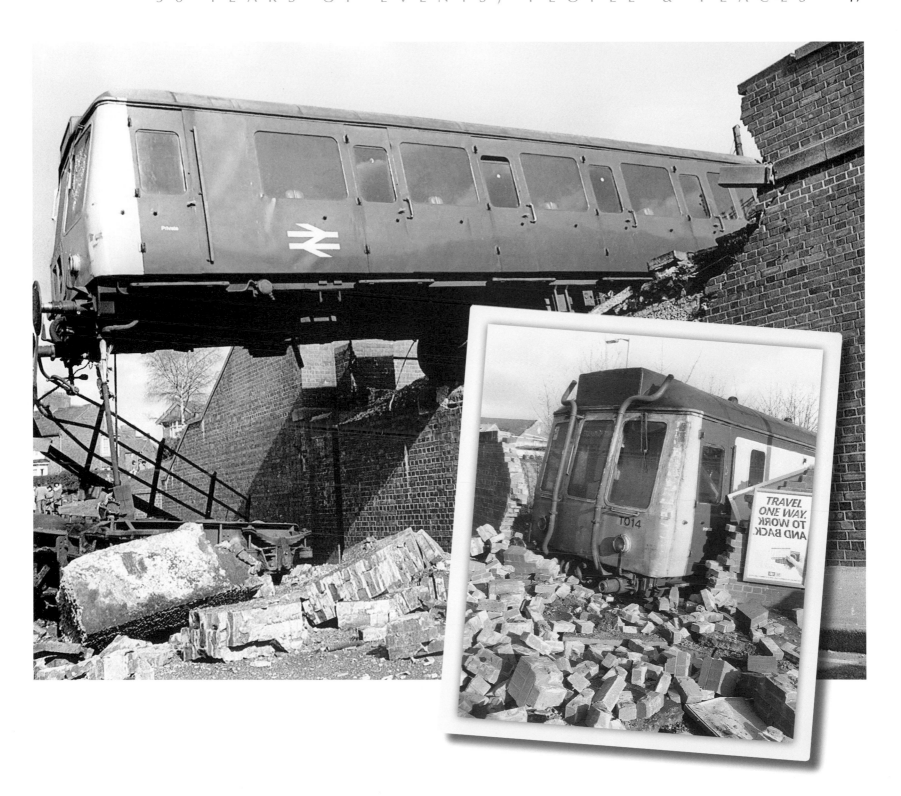

✦ The funeral of football legend Duncan Edwards at St Francis's Church, Dudley. Duncan was killed in the Munich Air Disaster along with seven of his Manchester United team-mates, eight journalists and three club staff in February 1958. This shot was taken from the church roof.

✦ Duncan Edwards's mother Sarah Ann Edwards, whom I got to know much later, puts fresh flowers on her son's grave.

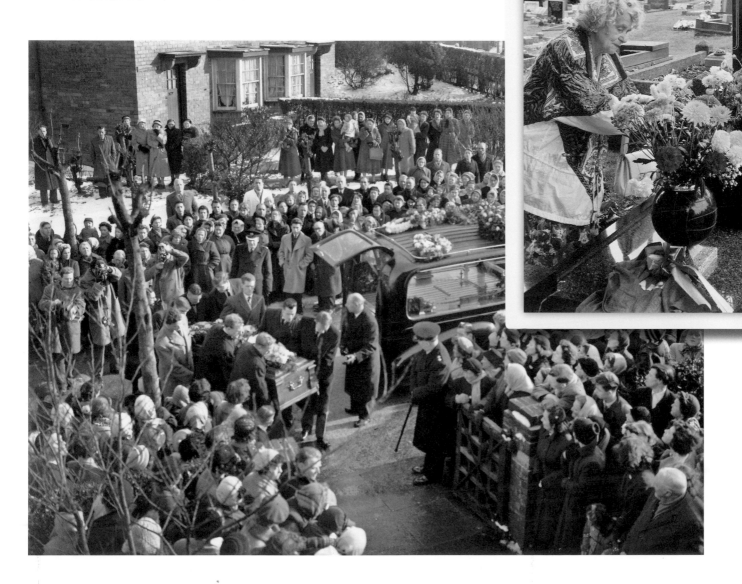

◆ Here we see some 250 investigating police officers gathered in Dudley Town Hall in February 1975 during the Lesley Whittle murder hunt. Leading the hunt for murderer Donald Neilson (nicknamed the Black Panther) was Chief Supt Bob Booth (centre). Neilson was on the run for eleven months.

◆ This dramatic shot shows a bailiff smashing down the door of the Coombes family home in Tipton during their eviction in 1965. In the 1960s there were many evictions in the Black Country and this is just one which I was sent to cover.

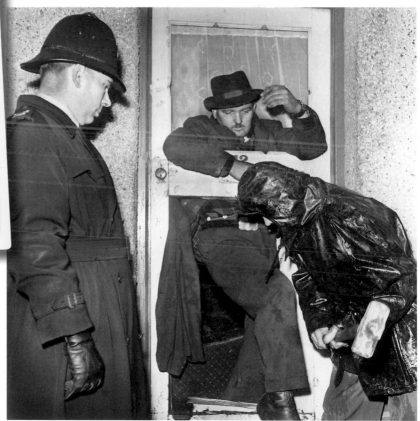

◆ During the homosexuality scandal between liberal MP Jeremy Thorpe and male model Norman Scott, reporter Tony Bishop and myself were sent to Chagford on Dartmoor to find Norman Scott, a former stable boy from Penn, Wolverhampton. This was a snatched shot of Scott riding on Dartmoor. He later invited us into his home for coffee but would not pose for pictures.

♦ Seventy-five-year-old Joshua Harris was held back by police when he tried to stop the council from demolishing two old houses he owned in Church Street, Lower Gornal, in 1977. The land was needed for redevelopment.

♠ Neighbours gather to watch police and bailiffs carry out the eviction.

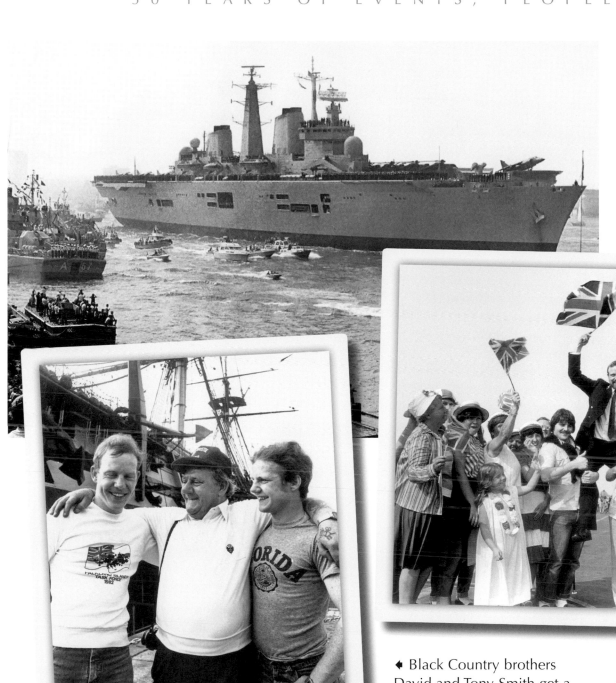

◆ An incredible scene of HMS *Invincible* coming out of the morning mist as she entered Portsmouth Harbour from the Falklands in 1982. Among the crew were Black Country lads.

◆ Black Country brothers David and Tony Smith get a welcome from their proud dad Harry Smith.

◆ Chief Stoker Dave Tisdale gets a lift from family and friends who had travelled from West Bromwich and Walsall to welcome him home from the Falklands.

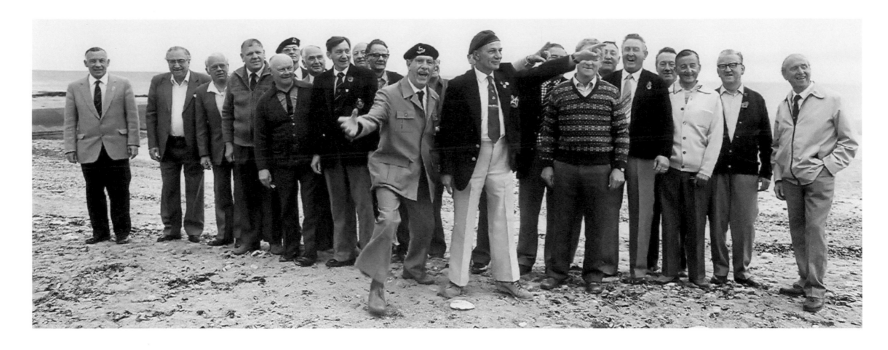

✦ Myself and reporter James Windle travelled to Normandy with some Black Country veterans on the fortieth anniversary of D-Day in June 1984. Pictured are some of the veterans in a jovial mood on Sword Beach.

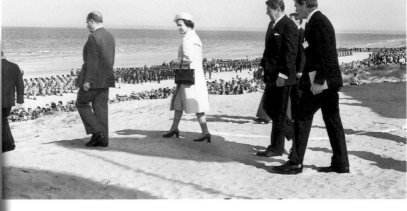

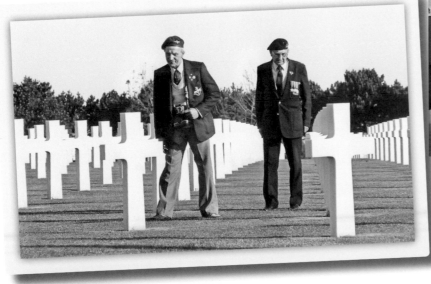

◄ In a more sombre mood two veterans search for fallen comrades in Bayeux Cemetery.

▲ Her Majesty the Queen and US President Ronald Reagan make their way onto Omaha Beach in 1984.

◆ A Black Country hen night featuring male stripper Andy Wade at the Saltwells pub, Quarry Bank, 1975. This picture went on to win the Midland News Picture of the Year award and was published worldwide. The Plymouth-based artist Beryl Cook based her painting 'Ladies Night' on this image. In 1975 male strippers were rare and the faces of the women along with the atmosphere made this a winning shot.

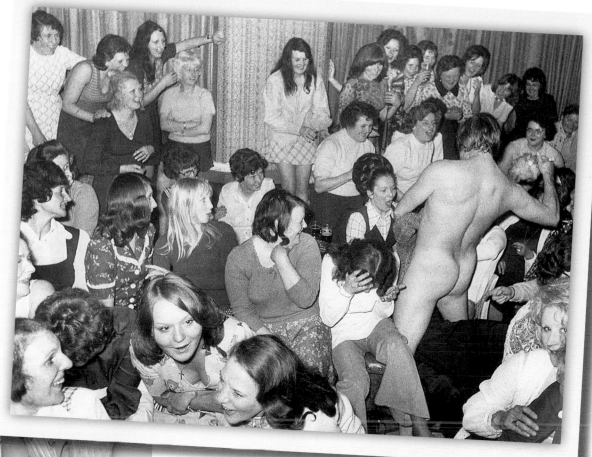

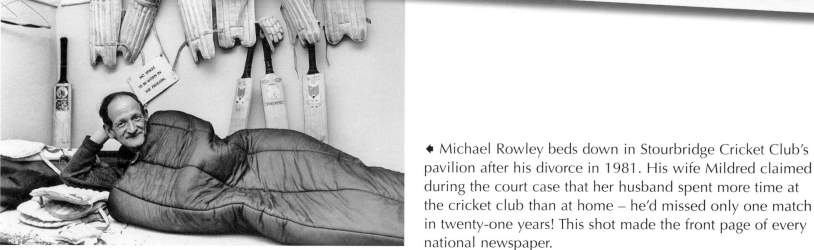

◆ Michael Rowley beds down in Stourbridge Cricket Club's pavilion after his divorce in 1981. His wife Mildred claimed during the court case that her husband spent more time at the cricket club than at home – he'd missed only one match in twenty-one years! This shot made the front page of every national newspaper.

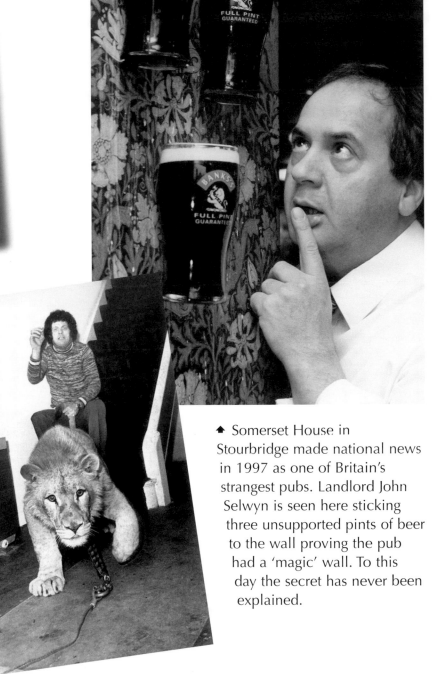

✦ While nine-year-old Paul Spencer of Stourbridge was on holiday in the Algarve, he fell 12ft from a diving board fracturing his skull on a concrete block. TV and radio personality Stuart Hall was near the pool and managed to keep Paul breathing until he got to hospital – although his heart had stopped twice. Later Stuart arranged for all the family to go back to Portugal for a week's holiday. Paul and Stuart are pictured on the set of the TV show *It's a Knockout* in Lancashire in 1980.

✦ Somerset House in Stourbridge made national news in 1997 as one of Britain's strangest pubs. Landlord John Selwyn is seen here sticking three unsupported pints of beer to the wall proving the pub had a 'magic' wall. To this day the secret has never been explained.

✦ There's just 8ft between Laddo the Lion and me when this picture was taken at the Cradley Heath home of Lewis Foley. In the 1970s the animal shared the family home with Foley's wife and three children and was kept in the bedroom.

ROYALS & POLITICIANS

During election time politicians appear like moths round a lamp and are keen to get publicity doing ordinary things, like playing bowls and snooker or even having a cup of tea. Royals on the other hand always make news. I never thought I'd win an award for a shot of a princess stuck in mud or photograph a prince at a market stall.

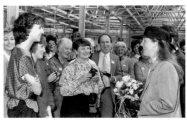

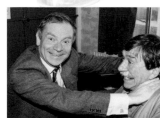

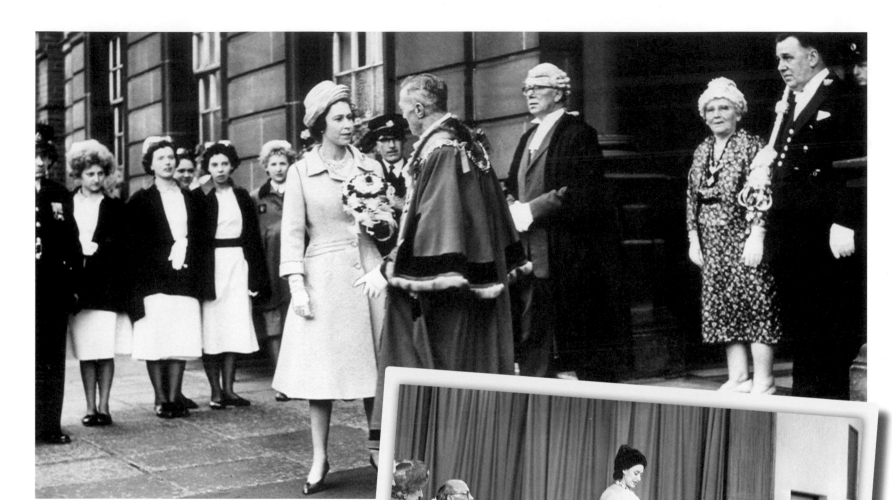

✦ Her Majesty the Queen on a visit to Wednesbury Town Hall in April 1962. She is pictured chatting to the mayor, Cllr Leonard Waldren, while Town Clerk George Frederick Thompson is on the right of picture.

✦ Princess Margaret is seen here opening the new £400,000 extension to Dudley Teacher Training College in 1962. Behind the princess is Principal David Jordan (wearing glasses). The building has now been demolished.

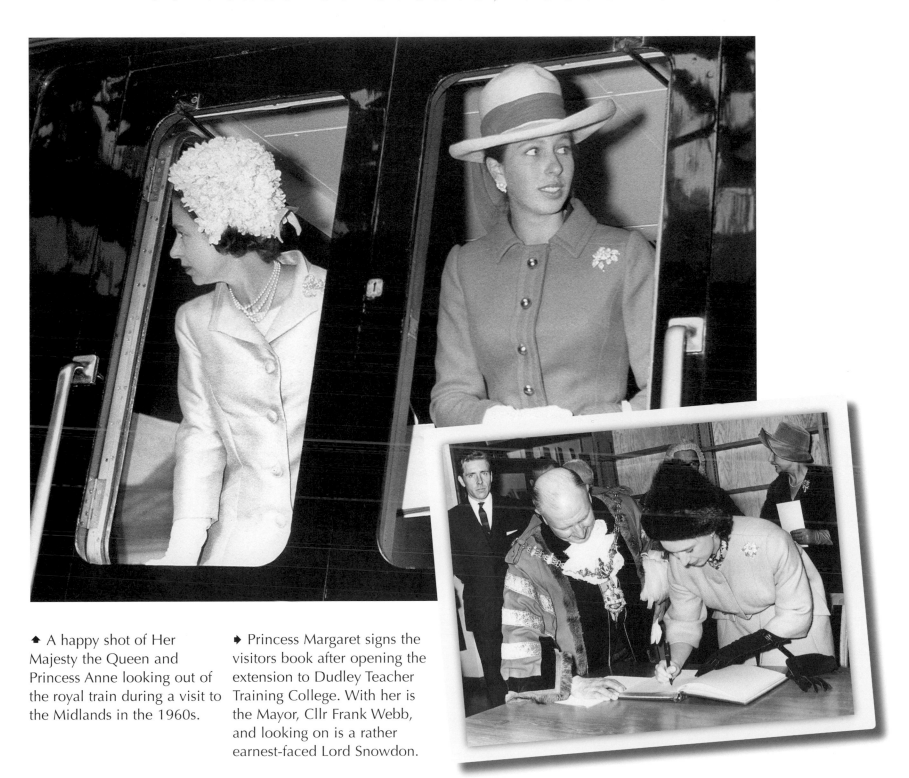

◆ A happy shot of Her Majesty the Queen and Princess Anne looking out of the royal train during a visit to the Midlands in the 1960s.

➤ Princess Margaret signs the visitors book after opening the extension to Dudley Teacher Training College. With her is the Mayor, Cllr Frank Webb, and looking on is a rather earnest-faced Lord Snowdon.

➧ Princess Anne at Brierley Hill Civic Hall in 1988 where she met members of the Townswomen's Guild from all over the West Midlands. She is pictured sharing a joke with Mrs Joan Abel, Chairman of the region's federation.

➧ Royals always make the headlines and this shot of Princess Alexandra picking her way cheerfully through farmyard muck at the Three Counties Show in June 1977 certainly did – it went on to win the National Royal Picture of the Year Award in the same year.

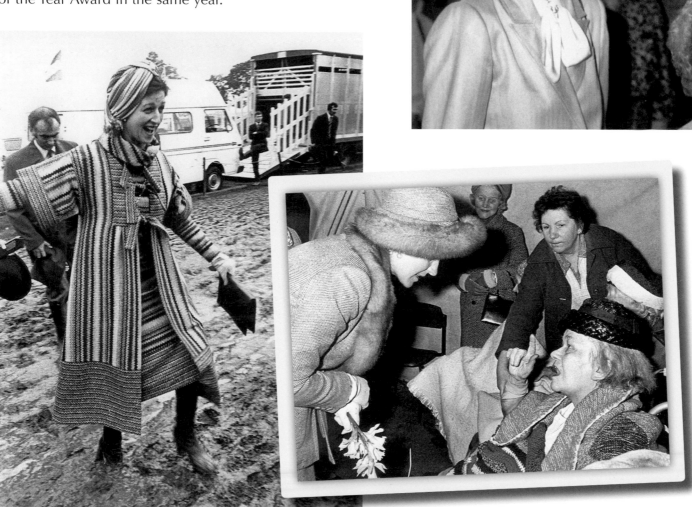

◄ The Duchess of Kent gets told off by a resident of an old people's home in Dudley during her visit to the Black Country in 1985.

✦ The Duchess of York chats to workers at Myers factory, Warley, in October 1987.

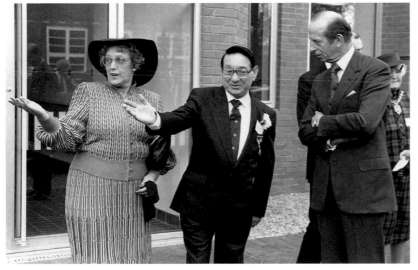

✦ Diana, Princess of Wales, during a tour of the area in 1986. This shot was taken at Kidderminster.

✦ A puzzled Duke of Gloucester is told which way to go by Cllr and Mrs Jack Wilson. The duke opened the J.T. Wilson Hall at Dudley College in 1993.

◆ Prince Charles shares a joke with traders on Dudley Market in February 1996. To get this shot I had to crawl under a series of stalls so that I was on the traders' side and facing the prince. It paid off, making the front page.

◆ Almost royal! Like the royal family, Margaret Thatcher made news wherever she went. She is pictured here in 1987 chatting to workmen while visiting a building site at Coseley.

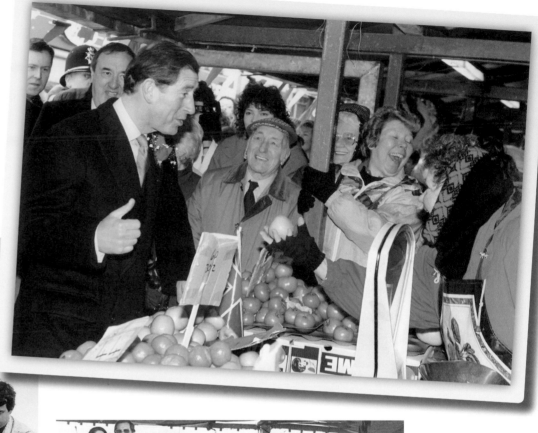

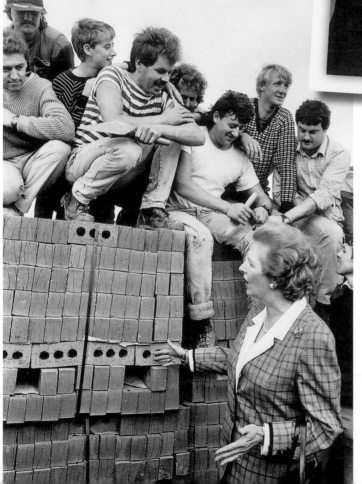

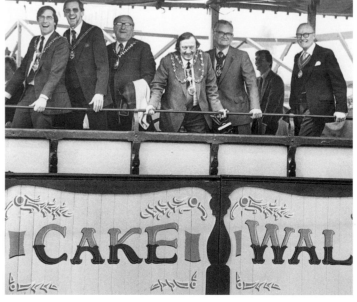

◆ Civic leaders from across the Black Country try to keep upright on the Cake Walk at the Black Country Living Museum's fairground.

◆ Norman Tebbit attempting to pot the red during a game of snooker with MP John Blackburn while on a visit to Dudley in 1987.

◆ This kid takes the biscuit! – Neil Kinnock chats to a little girl who is more interested in her snack than politics during his visit to the Black Country in March 1992.

◆ Surprise, surprise, John Prescott playing with blue balls! The former Deputy Prime Minister is pictured here in 1997 tenpin bowling in Brierley Hill.

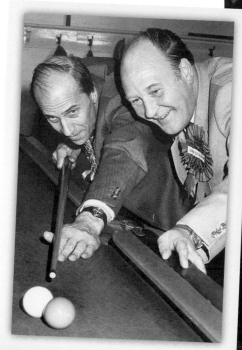

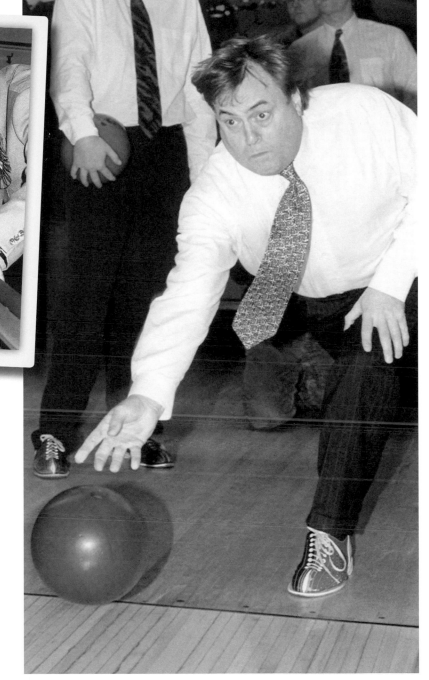

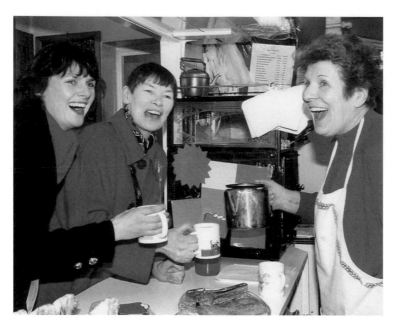

◆ Oscar-winning
actress Glenda
Jackson, who later
turned to politics, is
seen here with former
MP Debra Shipley
pausing for a cuppa
in a Stourbridge café
in 1997.

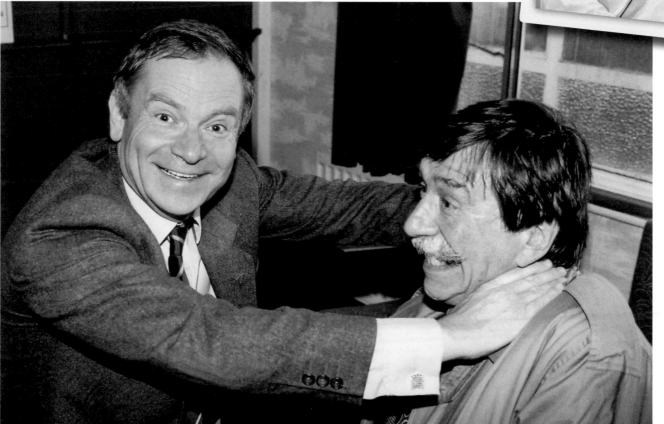

◆ Tony Blair was the
golden boy of British
politics when this picture
was taken during his tour of
the Black Country in 1995.

◆ A favourite shot of
mine – Jeffrey Archer
attempts to strangle a
colleague, reporter Tony
Bishop, while he was
interviewing him. It was
always fun working with
Tony.

CHAPTER 3

SHOWBIZ

Surprisingly enough, over the years the Black Country has been a popular choice for film and TV locations. This is mainly due to the ready-made streets and houses at the Black Country Living Museum and a few miles away, the magic of steam on the Severn Valley Railway.

Among my images of showbiz stars are two rarely seen pictures of Dudley-born Lenny Henry when he was at school, and later in the Black and White Minstrel Show. We'll also encounter a very young Kenneth Branagh and a kind gesture from Johnny Morris to a financially troubled zoo.

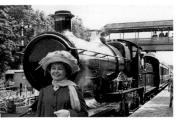
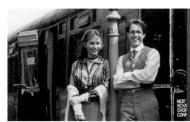
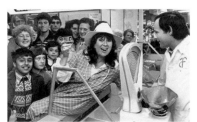

◆ When this film about the murder of seventeen-year-old heiress Lesley Whittle was being shot in Dudley in 1977 only two years after her killing, there was a public outcry. Donald Sumpter, playing the part of Donald Neilson, is pictured during filming of *The Black Panther Story*. The company were a little nervous about the press taking pictures, but I managed to get this shot of the lead actor. The film did not take off in this country but found a market in the USA and Canada.

◆ An almost unrecognisable Kenneth Branagh chats to actress Felicity Montagu during the filming of *Coming Through* at the Black Country Living Museum in 1985. This made-for-TV film was about the early life of D.H. Lawrence and scripted by Alan Plater.

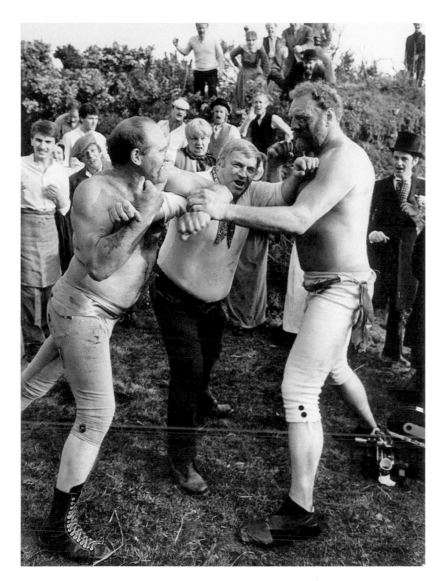

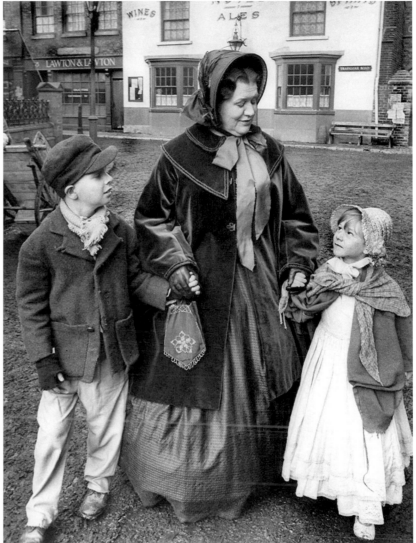

♠ Actors Gordon Corbett (left) and Pat Roach (right) are refereed by Black Country actor and landlord Ray Hingley, during the filming of a bloody bare-knuckle fight between the Tipton Slasher and his rival Tom Sayers for a TV film shot in Netherton during the summer of 1984. The Tipton Slasher, real name William Perry, was the Mike Tyson of his day and is buried in St John's churchyard, Kates Hill, Dudley.

♠ Patricia Routledge walks along the Black Country Living Museum street with two children from the cast of the TV production of *Sophia and Constance*. The BBC spent many weeks at the museum filming this major series in 1987.

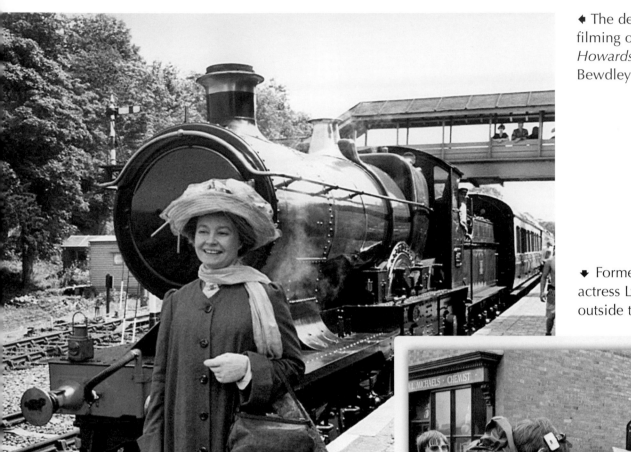

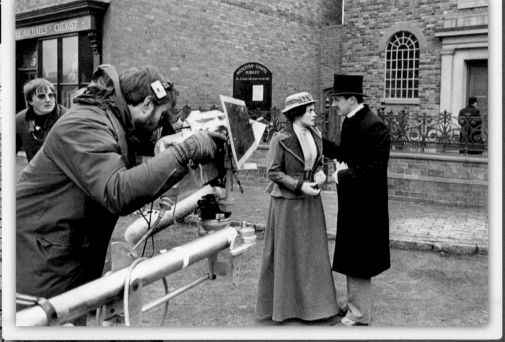

◆ The delightful Prunella Scales during the filming of the Merchant Ivory production *Howards End* on the Severn Valley Railway at Bewdley in July 1991.

◆ Former Doctor Who Peter Davison and actress Lynsey Beauchamp shooting a scene outside the Wesleyan chapel at the museum.

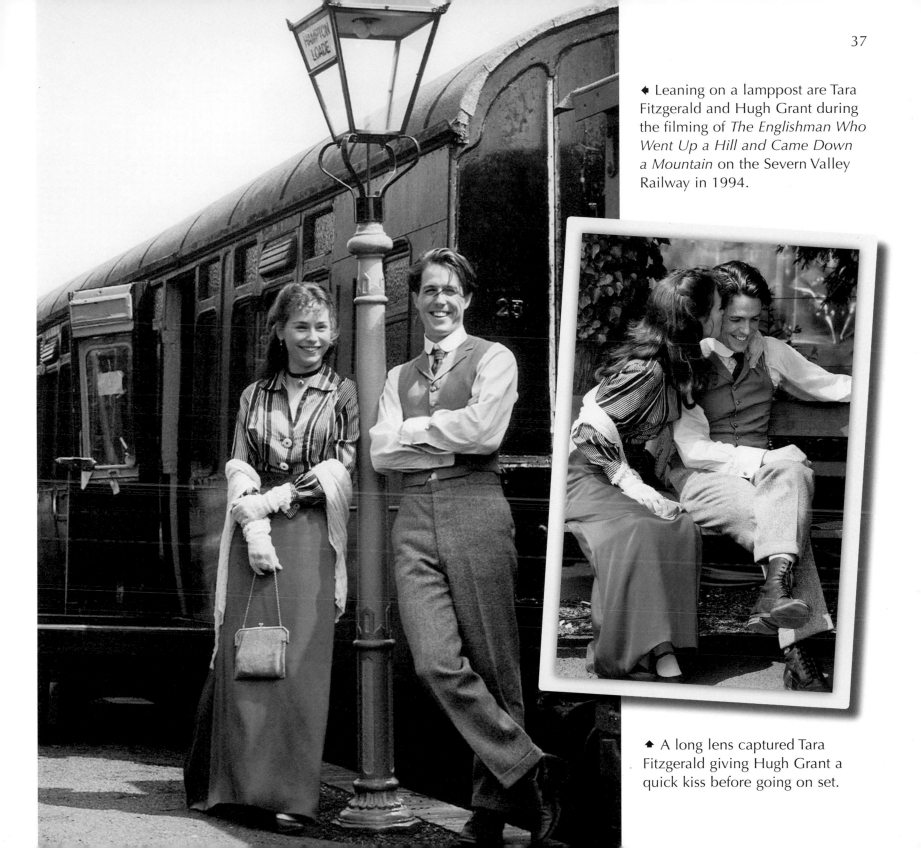

◆ Leaning on a lamppost are Tara Fitzgerald and Hugh Grant during the filming of *The Englishman Who Went Up a Hill and Came Down a Mountain* on the Severn Valley Railway in 1994.

◆ A long lens captured Tara Fitzgerald giving Hugh Grant a quick kiss before going on set.

◆ John Thaw filming *Good Night Mr Tom*. I recall he was in a bad temper when I took this picture on Arley station in April 1998 – but we all have our off days.

◆ Jolly Su Pollard blows her own trumpet on Arley station during the filming of *Oh! Doctor Beeching* with fellow actor Felix Bowness and members of the Stourport Brass Band in May 1997.

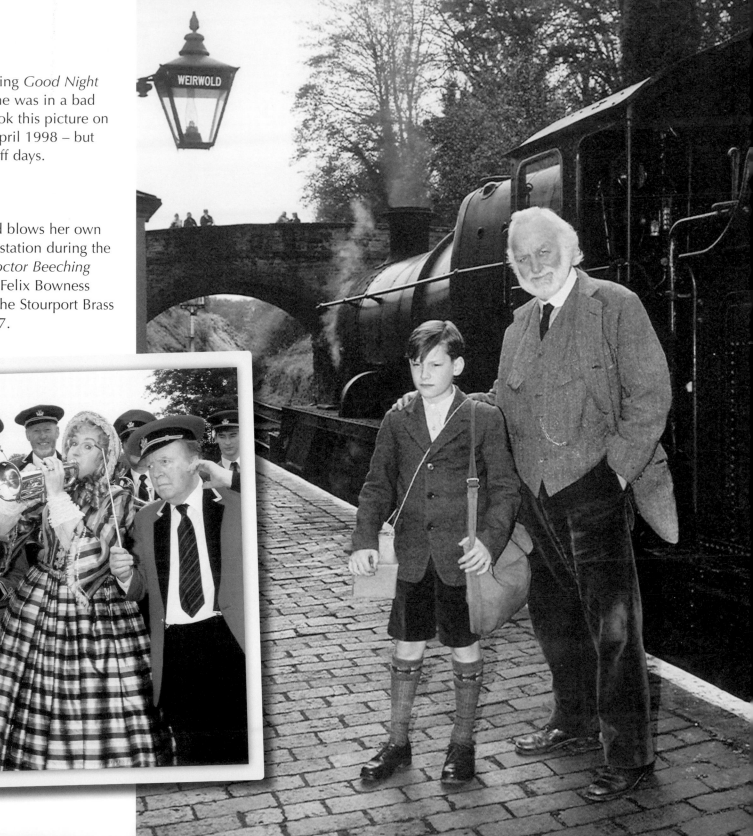

✦ Carry On stars Kenneth Williams and Barbara Windsor join Bernice Fairman from Stourbridge at Pinewood Film Studios in 1977. Bernice was Stourbridge Jubilee Queen and won a trip to the world-famous studios where she toured film sets and mixed with the stars.

✦ Black Country actor Chris Gittins, who was best known for his role as Walter Gabriel in the long-running radio serial *The Archers*, commissioned artist Robin Jennings in 1981 to paint a picture of Kinver Edge. Chris, who had spent boyhood trips with the Scouts camping at Kinver, wanted a reminder of those happy days.

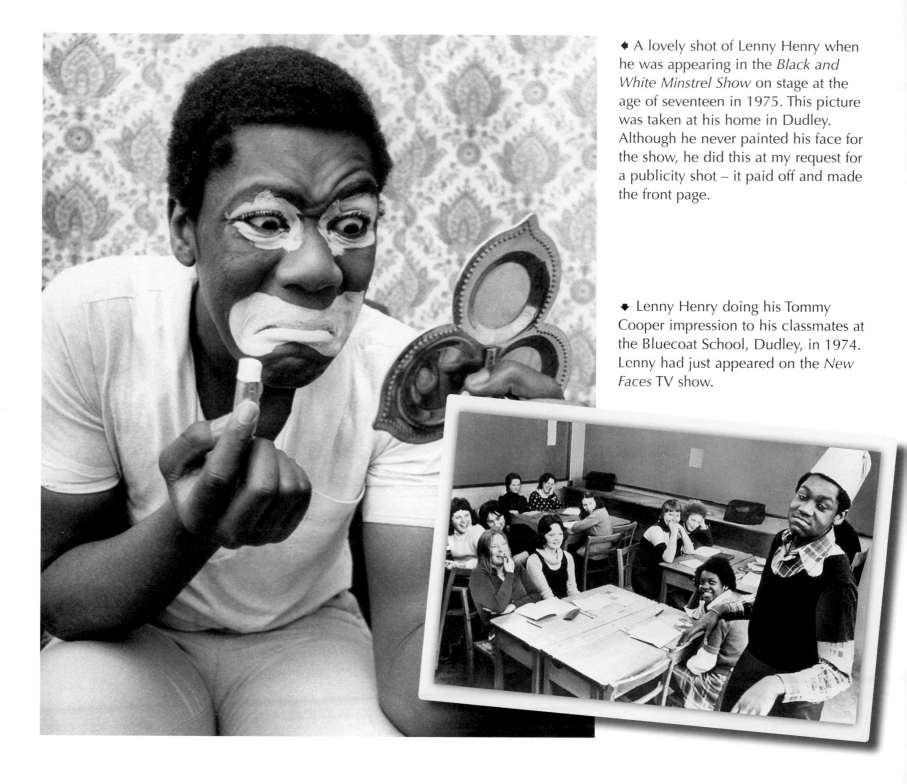

◀ A lovely shot of Lenny Henry when he was appearing in the *Black and White Minstrel Show* on stage at the age of seventeen in 1975. This picture was taken at his home in Dudley. Although he never painted his face for the show, he did this at my request for a publicity shot – it paid off and made the front page.

◆ Lenny Henry doing his Tommy Cooper impression to his classmates at the Bluecoat School, Dudley, in 1974. Lenny had just appeared on the *New Faces* TV show.

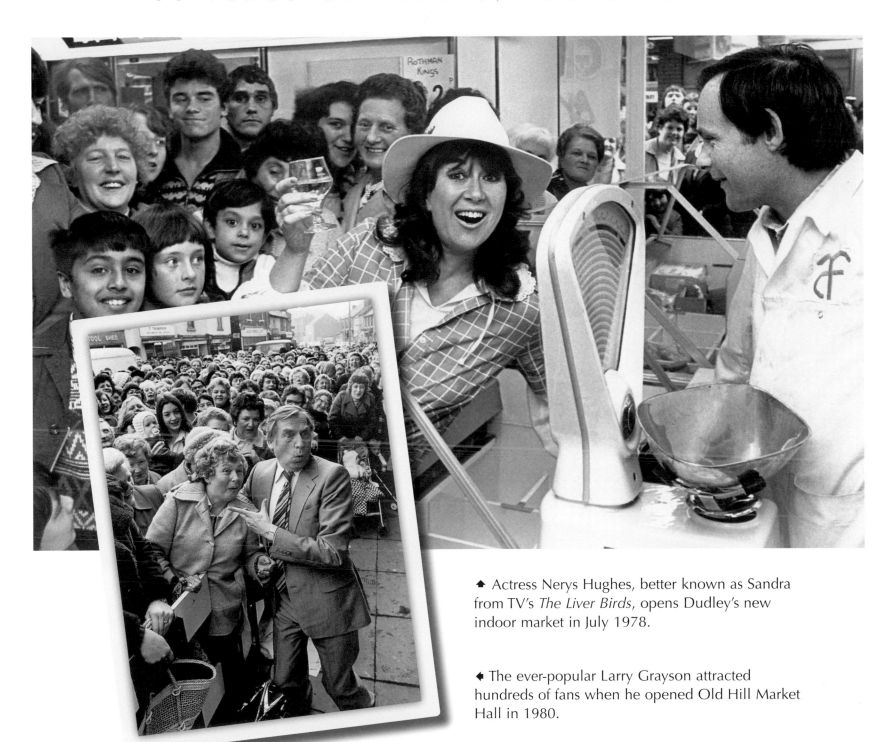

♠ Actress Nerys Hughes, better known as Sandra from TV's *The Liver Birds*, opens Dudley's new indoor market in July 1978.

♠ The ever-popular Larry Grayson attracted hundreds of fans when he opened Old Hill Market Hall in 1980.

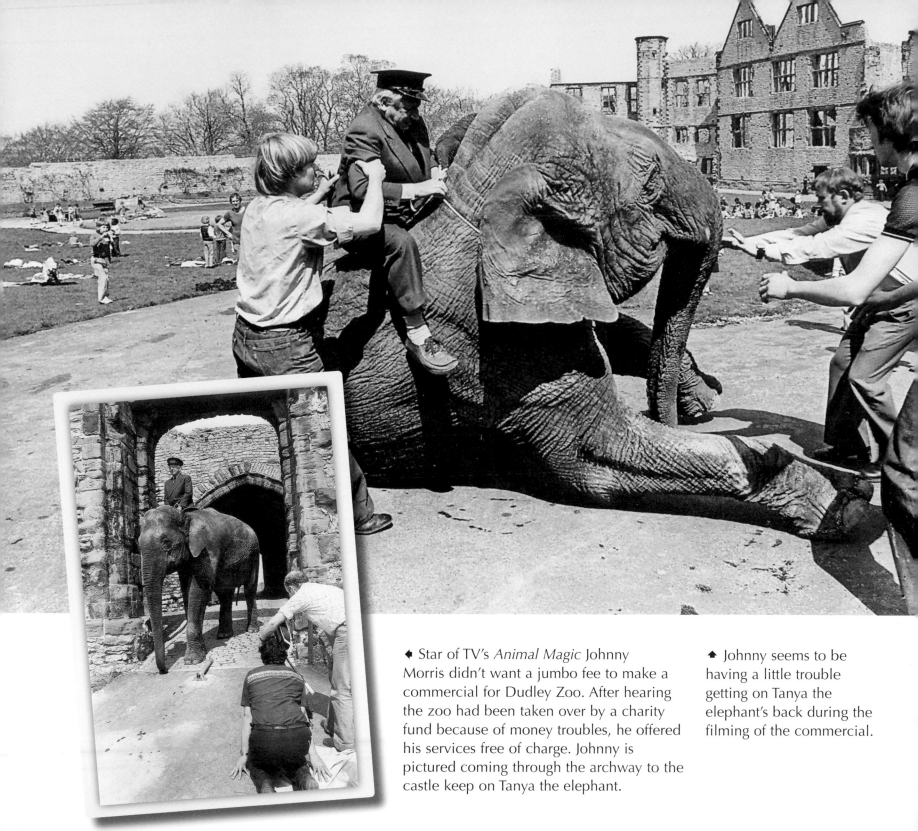

◆ Star of TV's *Animal Magic* Johnny Morris didn't want a jumbo fee to make a commercial for Dudley Zoo. After hearing the zoo had been taken over by a charity fund because of money troubles, he offered his services free of charge. Johnny is pictured coming through the archway to the castle keep on Tanya the elephant.

◆ Johnny seems to be having a little trouble getting on Tanya the elephant's back during the filming of the commercial.

↟ Little and Large were appearing in *Dick Whittington* at the Grand Theatre Wolverhampton when this picture was taken. I borrowed the theatre cat for this publicity shot, but it took a dislike to the comedy double act and bolted into the wings.

↟ Jane Asher took to the wheel of this fun bus when she opened the Merry Hill Tourist Centre in June 1996.

↟ The late Rod Hull is seen here in his heyday filming his TV show with the infamous Emu at Dudley Zoo.

◆ Cilla Black appearing with the pop band 21st Century Girls at the Merry Hill Centre in 1996.

◆ The great Black Country comics Aynuk and Ayli, John Plant (left) and Alan Smith, having fun with Sister Sarah Jones at Russells Hall Hospital in 1991. They were the very best to photograph and we became good friends over the years. John sadly died in 2006, but Alan is going strong and is still keeping the Black Country folk laughing.

CHAPTER 4

SEASONS AND WEATHER

The British weather always makes news and it gives press photographers the chance to illustrate our changeable climate. Here are just a few of the hundreds of pictures I have taken over the years – from a marooned pub and cars stuck in the snow to keeping zoo animals cool, and from a chain maker with a thirst to a beautiful sunset and hoarfrost.

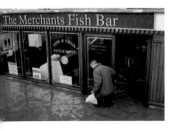

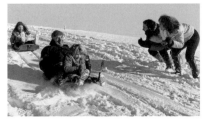
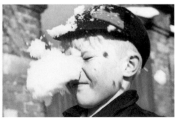
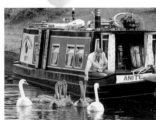

◆ The landlord of the Mug House, Bewdley, Jimmy Paterson kept his pub open despite being underwater from the flooding River Severn in 1990.

◆ Wet fish and chips – a watery scene outside a Bewdley fish and chip shop during the flooding of the Severn.

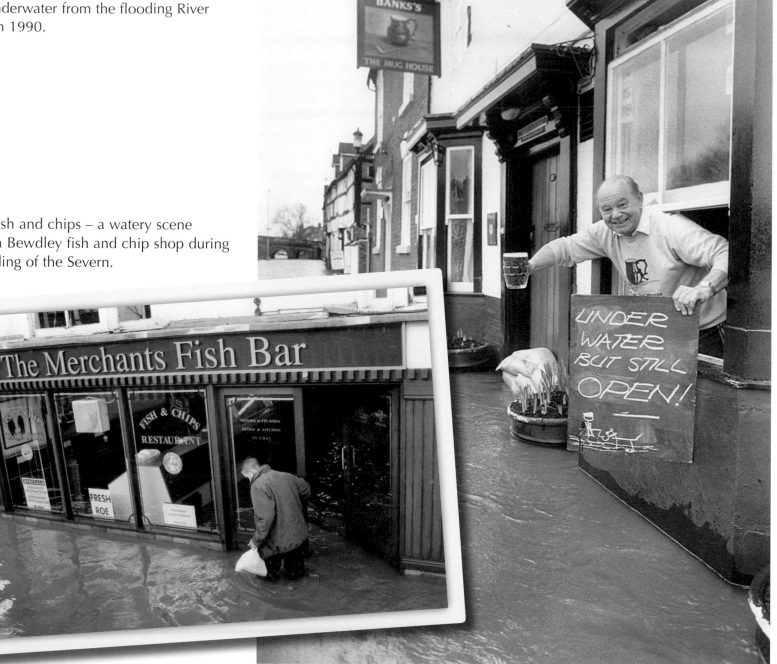

➧ High on a hill near Enville
a walker passes a bare tree
which stands out against a
wintry sky.

◆ True grit – gritting Oakham Road,
Dudley, during the winter of 1956.

◆ There's trouble in the snow as vehicles slip and slide in Watsons Green Road, Kates Hill, during the winter of 1963.

◆ Keith Keeling, a pupil from Kates Hill Junior School, Dudley, gets a snowball full in the face in January 1956. This picture was taken with a VN glass plate press camera which only took one image at a time, so I had to get it right first time or I'd have missed the picture altogether.

◆ Nigel Jackson is seen here breaking the ice from around his floating home in Dudley during the winter of 1991.

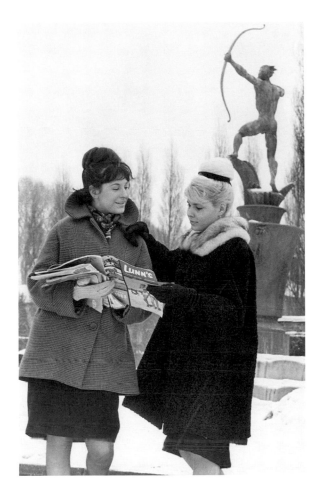

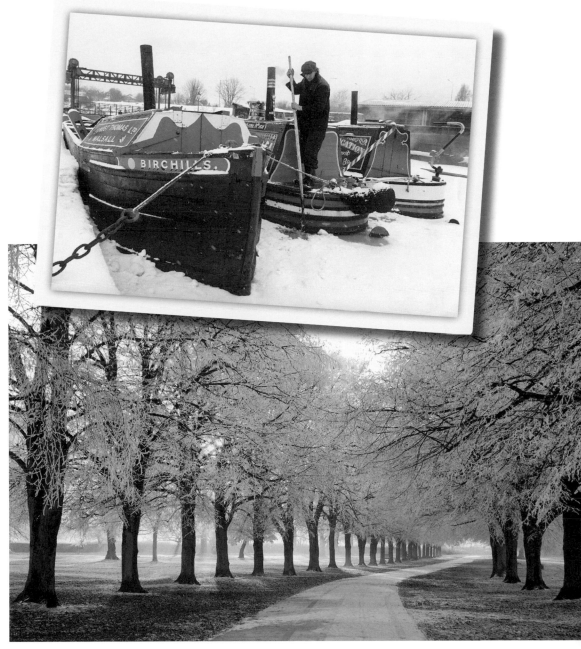

◆ Two girls in the snow study a holiday brochure and dream of summer. This was taken in Coronation Gardens in Dudley during the winter of 1963. Beehives were clearly the hair fashion of the time.

◆ A stunning sunset is seen against the hoar frosted trees in the grounds of Himley Hall.

◄ Chugging peacefully along the Staffordshire & Worcestershire Canal on a bright autumn morning.

◄ A family enjoying some sledging fun in the snow near Wombourne.

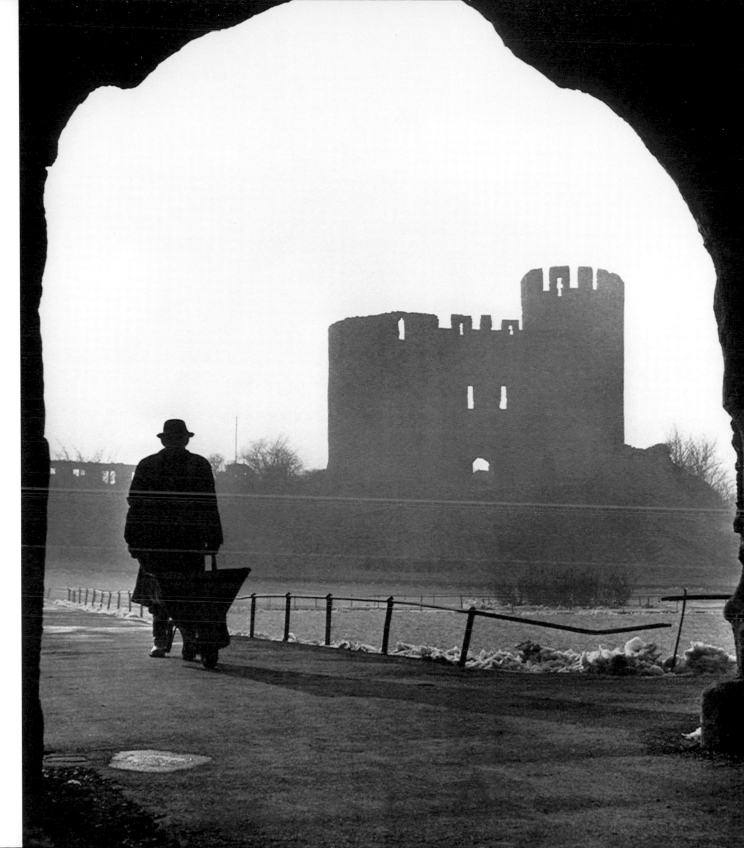

◆ A man and his wheelbarrow in the courtyard of Dudley Castle makes for a dramatic shot on a cold winter's day in 1958.

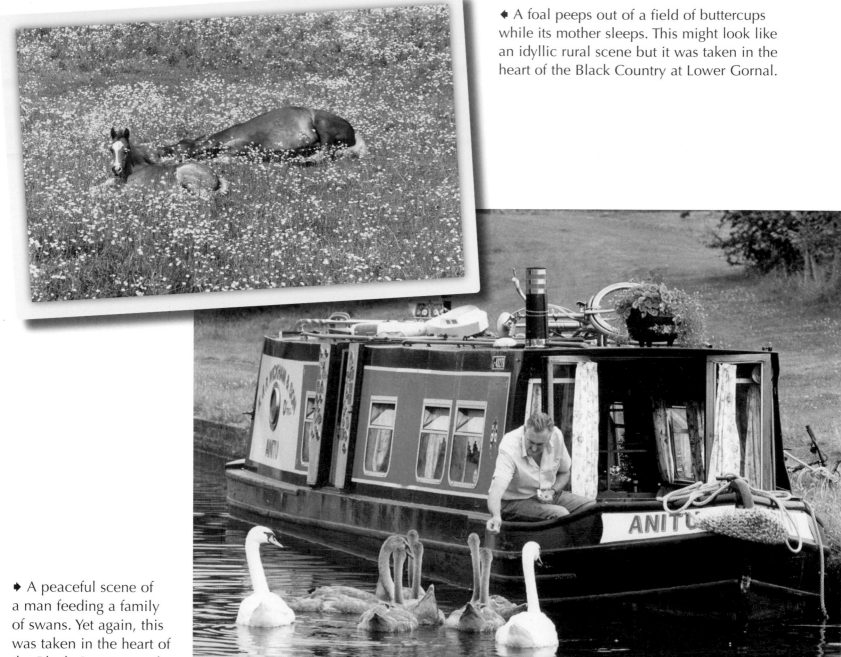

◀ A foal peeps out of a field of buttercups while its mother sleeps. This might look like an idyllic rural scene but it was taken in the heart of the Black Country at Lower Gornal.

▶ A peaceful scene of a man feeding a family of swans. Yet again, this was taken in the heart of the Black Country on the canal at Bumble Hole, Netherton.

◆ One little Black Country lass knew a surefire way of keeping cool in the summer of 1959.

◆ Dudley Zoo curator Chris Round keeps Tim the tapir cool in the very hot summer of 1976.

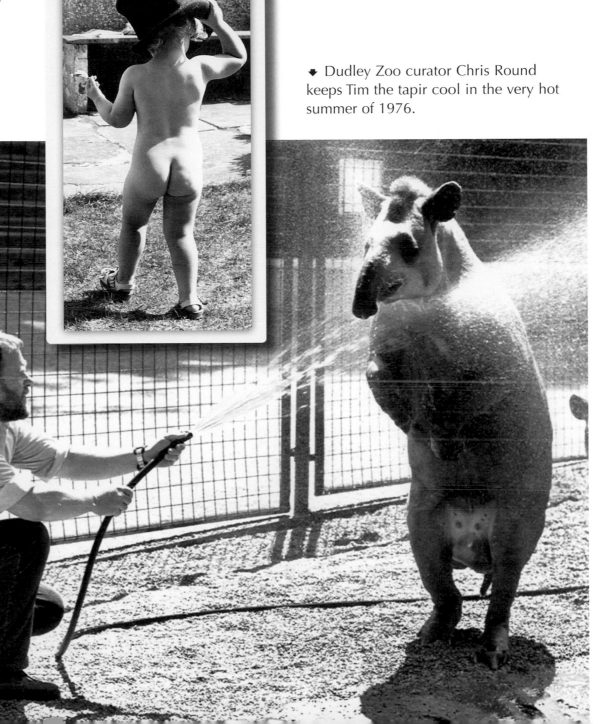

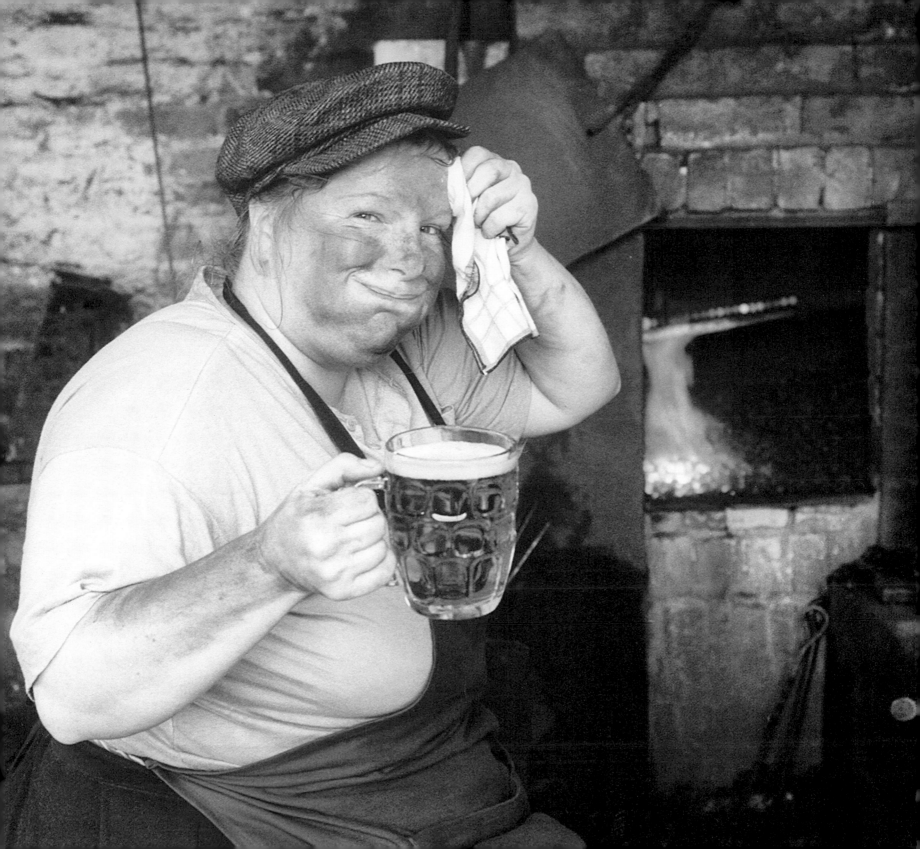

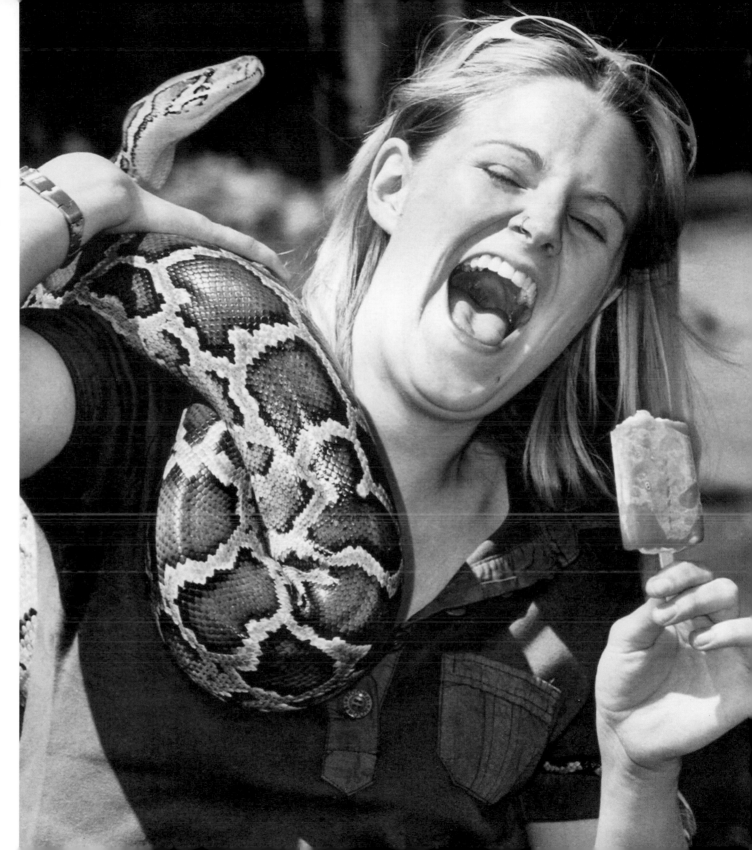

◆ Black Country chainmaker Sheila Fullard is seen here keeping her temperature down at the furnace with a pint of cool beer in the summer of 1989.

➧ Keeping a cool head is rather difficult when you have an Indian Python who would rather like to share your lollipop at Dudley Zoo.

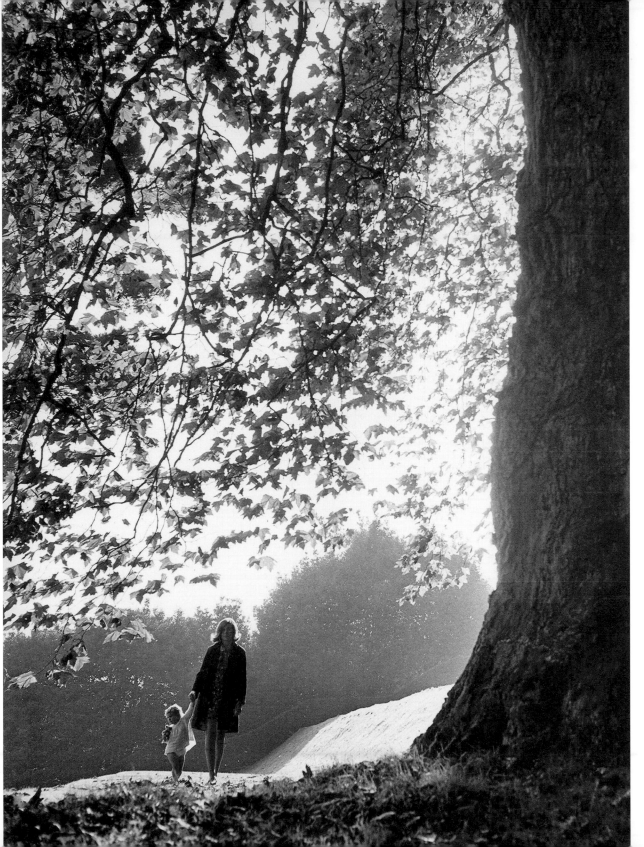

◄ A beautiful shot as a mother and child take a walk in the autumn sun through the park at Stourbridge.

ANIMALS AND CHILDREN

Animals and children have been a favourite theme of mine: they both act naturally and unexpectedly which makes for good pictures, but patience is needed.

For a photographer it can be quite trying to keep five puppies in Christmas stockings, a baby lemur on a banana or marshal a dozen boys looking through a pipe upside down.

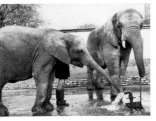
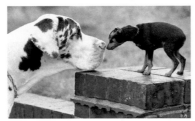
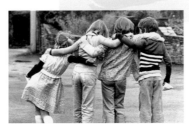

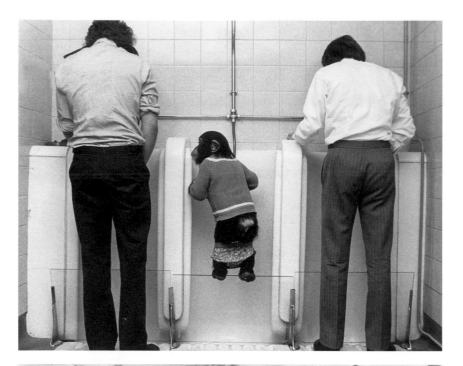

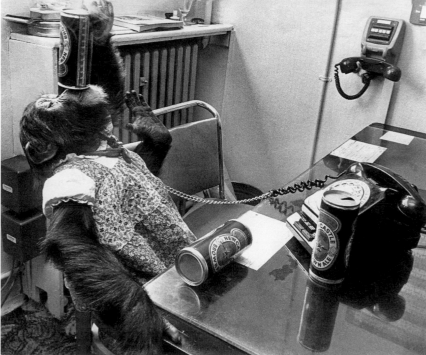

◆ No matter where his keeper went, Koko the Dudley Zoo chimp was not far behind.

◆ Red-eyed Pepe had nine females to keep him company but was never very friendly. He had a habit of throwing excrement at the public and was a very good shot, as I found out one day when I got hit full in the face while attempting a close-up of him.

◆ Koko again up to her tricks, this time in the manager's office at the Plaza Cinema, Dudley, in 1978. Koko was a friendly animal and was always good for pictures.

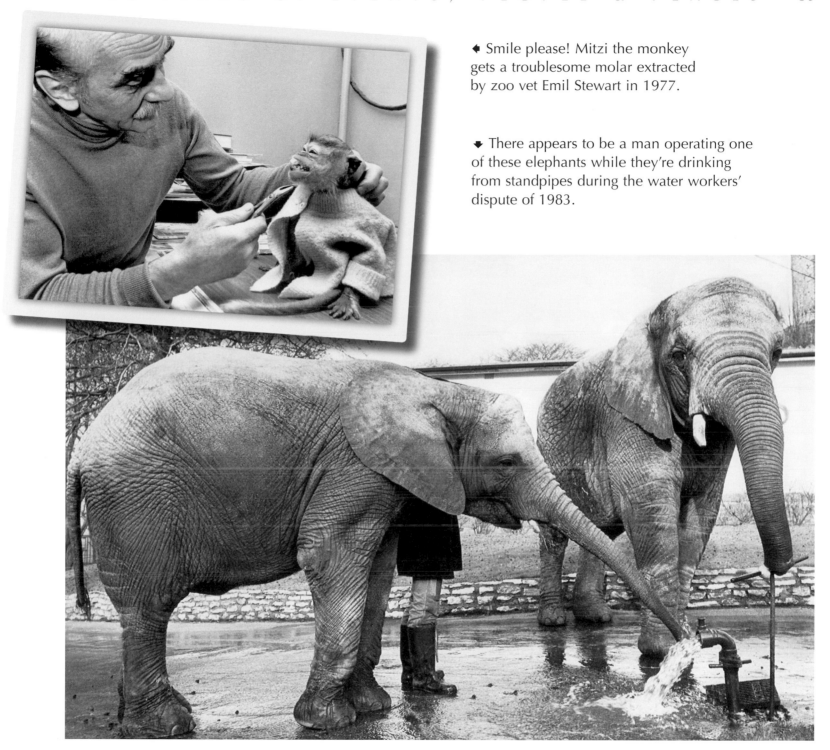

◄ Smile please! Mitzi the monkey gets a troublesome molar extracted by zoo vet Emil Stewart in 1977.

◄ There appears to be a man operating one of these elephants while they're drinking from standpipes during the water workers' dispute of 1983.

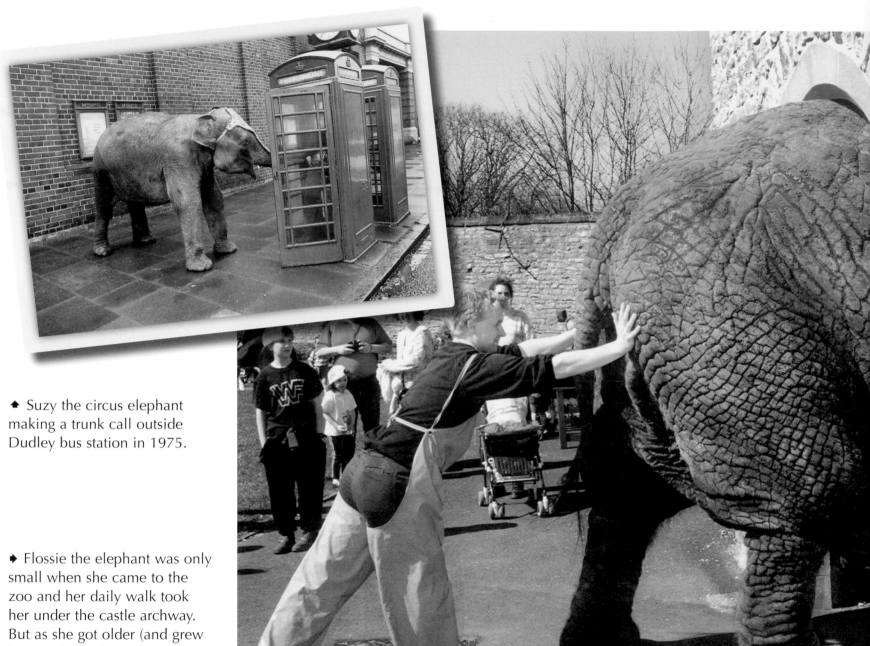

● Suzy the circus elephant making a trunk call outside Dudley bus station in 1975.

● Flossie the elephant was only small when she came to the zoo and her daily walk took her under the castle archway. But as she got older (and grew bigger) the archway became too small for her but she still insisted on the same old route . . . with a little help from her keeper, Nigel Summerfield.

◆ What a beautiful baby llama – but hang on! zookeeper Joanne Blount appears to have grown a pair of llama ears?

◆ Titus the South American tapir inspects eight local schoolgirls when they became keepers for the day at Dudley Zoo.

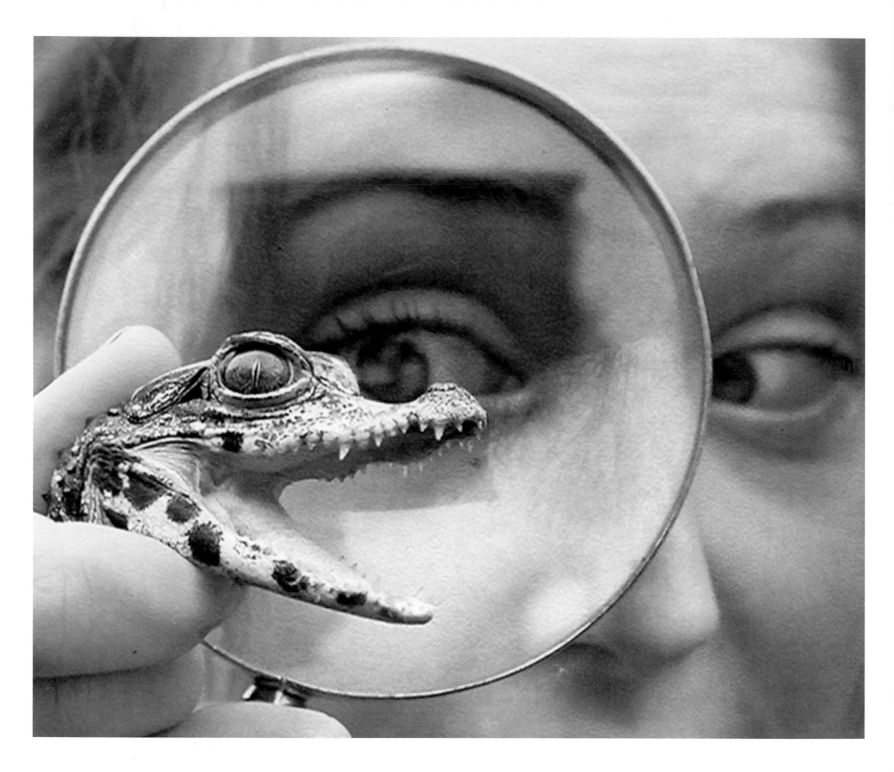

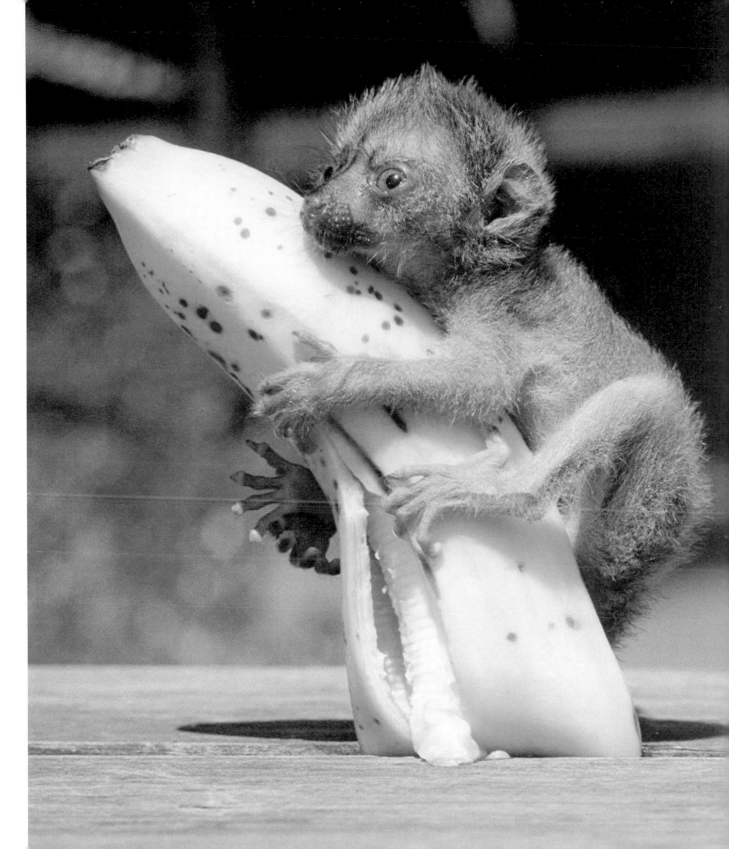

◆ The keeper's going croc-eyed and getting a close-up view of a newly hatched crocodile at Dudley Zoo.

◆ Matt the lonesome lemur hangs on to his dinner after being abandoned by his mother. He was looked after in Dudley Zoo's animal hospital until he was strong enough to join his primate friends.

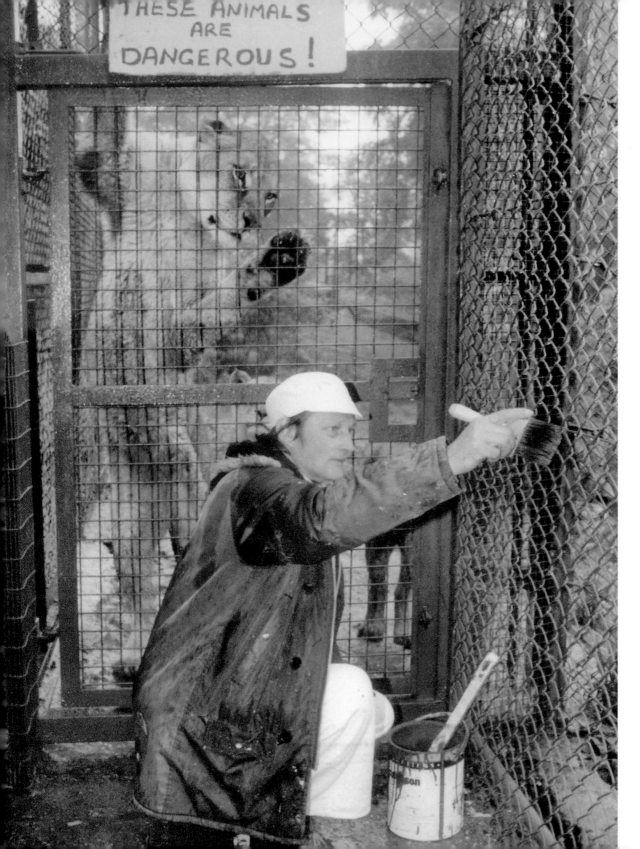

THESE ANIMALS ARE DANGEROUS!

◆ You've missed a bit! Emma the lioness keeps a sharp eye on Tom Edwards as he paints the fence around her enclosure.

◆ Milking the goat in the kitchen was a daily routine for Mrs Krystyna Stewart of Abberley Street, Dudley, in the 1970s. Daisy was her pet and she supplied enough milk for all the family.

◆ Making friends at a Black Country dog show are a Great Dane and a Miniature Pinscher.

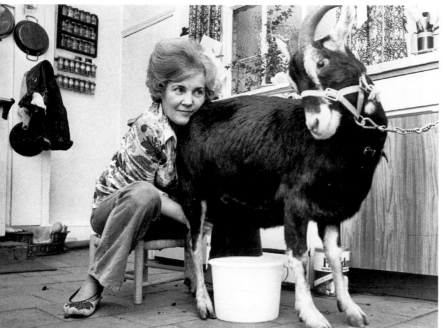

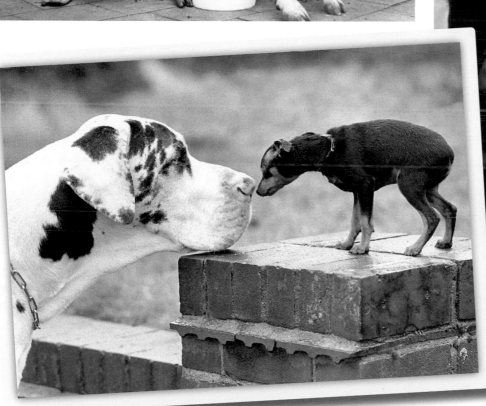

♠ Couch pooches settle down to watch *Match of the Day* at Long Meadow Boarding Kennels, Himley.

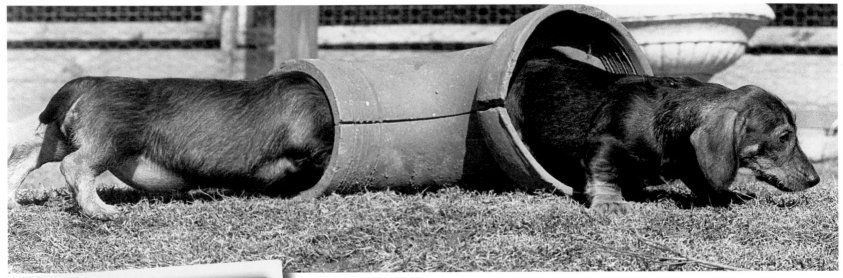

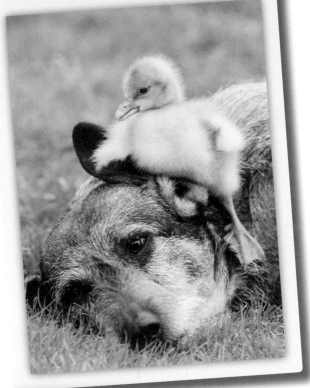

✦ The long and the short of it! Two Dachshunds playing in a pipe appear to be one long dog.

✦ The prospects were looking bleak for this gosling after his mother and the rest of the family were killed by a fox, but he was taken in and cared for by Mike Williams at his home in Himley Road, Dudley, and made friends with Mike's dog, Tasha.

✦ A sheep in the baa! Landlady Margaret Valance bottle-feeds these sheepish customers at the The Hillcrest pub in Kingswinford.

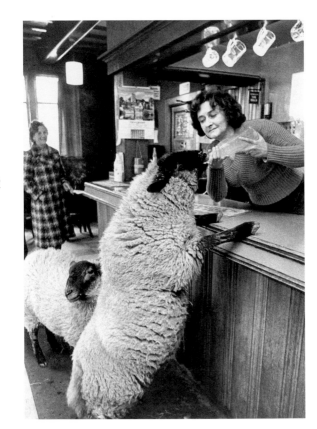

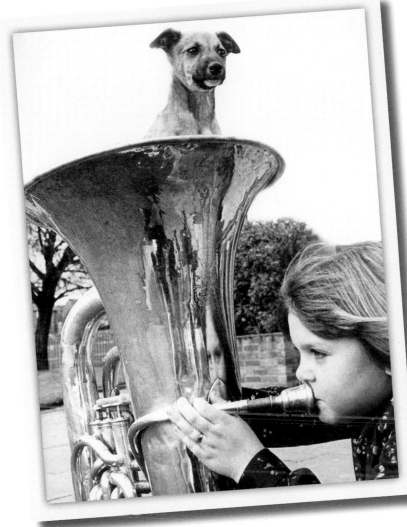

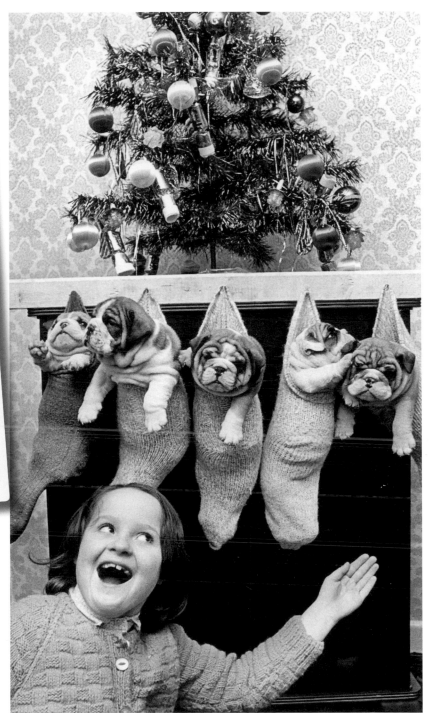

✦ This shot was to illustrate a spring festival in the Black Country which had brass bands and whippet racing. Young whippet Maggie fitted perfectly into the tuba of Karen Bradford.

✦ Jane Holloway is so happy with five puppies in her Christmas stockings. Her dad Richard Holloway of Brierley Hill was a bulldog breeder and let her keep one as a Christmas present in 1979.

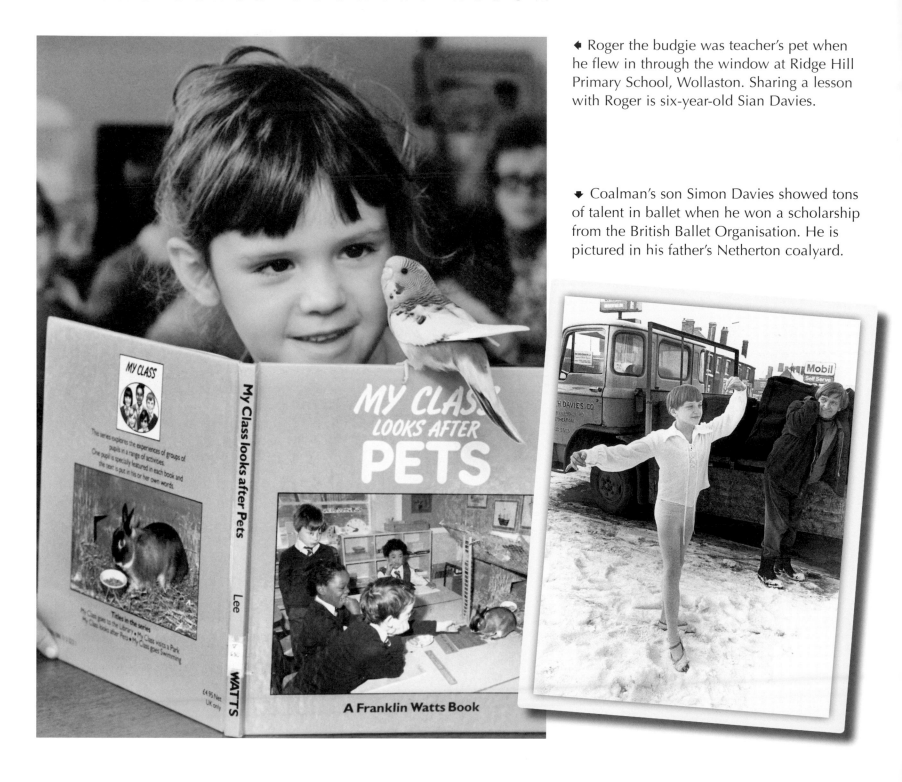

◆ Roger the budgie was teacher's pet when he flew in through the window at Ridge Hill Primary School, Wollaston. Sharing a lesson with Roger is six-year-old Sian Davies.

◆ Coalman's son Simon Davies showed tons of talent in ballet when he won a scholarship from the British Ballet Organisation. He is pictured in his father's Netherton coalyard.

◆ The amazing dart-throwing of 18-month-old Jarred Watkins of Sledmere Estate, Dudley, got him on to TV. He was never without his dummy when stepping up to the oche.

◆ Nine-year-old Dale Preston shapes up to Mr Universe, Dave Johns of Los Angeles, when he met the bodybuilder in Stourbridge in 1981.

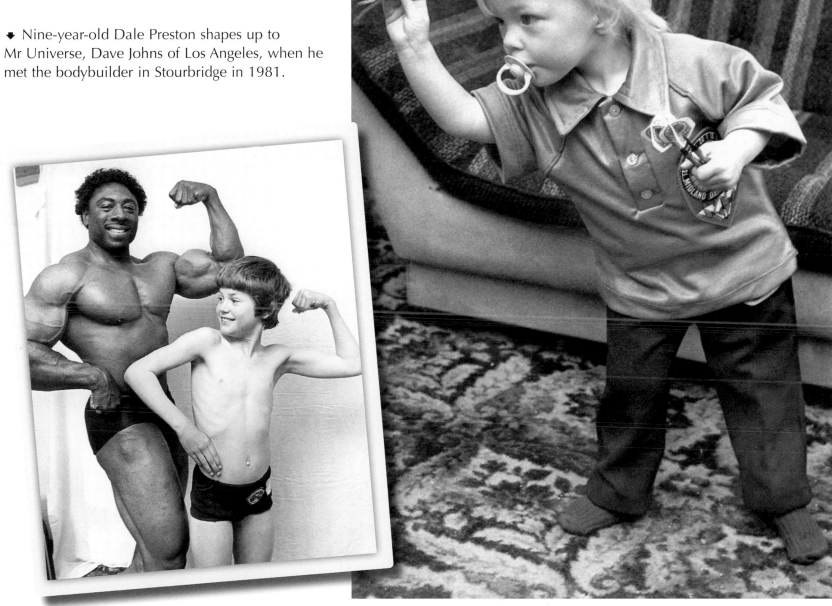

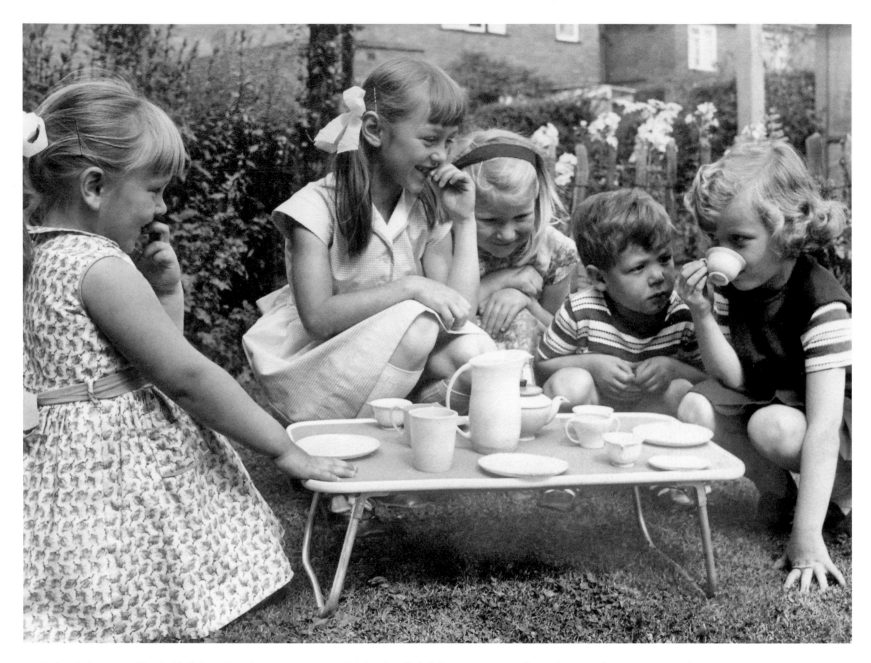

✦ What's it taste like? Children having a tea party in Springfield Crescent, Dudley, during the summer of 1965.

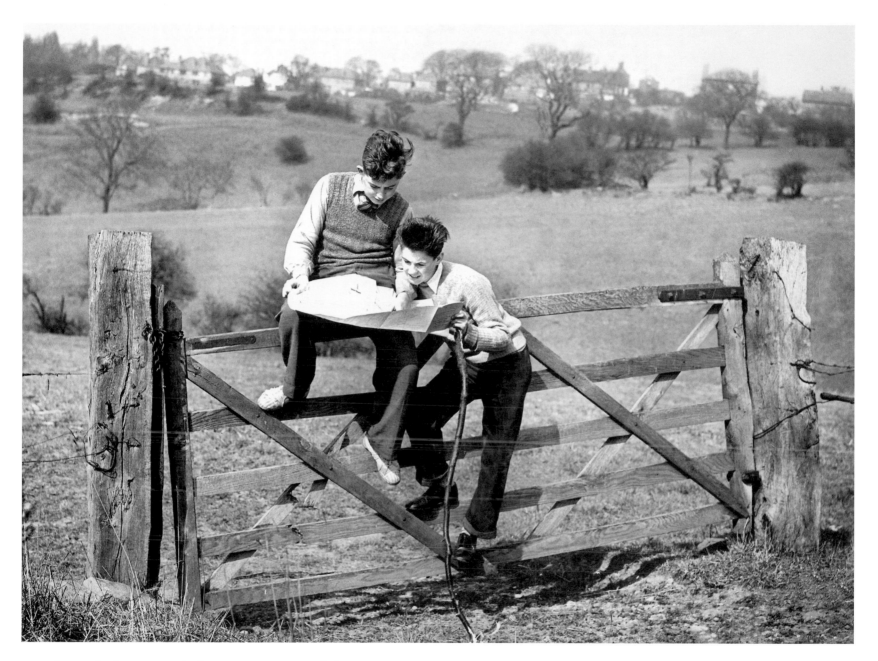

◆ Hiking Black Country lads Roger Lissimore (left) and Bob Vanes, check their map during a cross-country walk in 1956. They were my boyhood pals and we are still good friends nearly sixty years later. They were helping me out at the time for a feature on Easter activities.

◆ Two Black Country kids photographed on the Priory Estate, Dudley, in 1958.

◆ Children having great fun playing in the street – pals for ever.

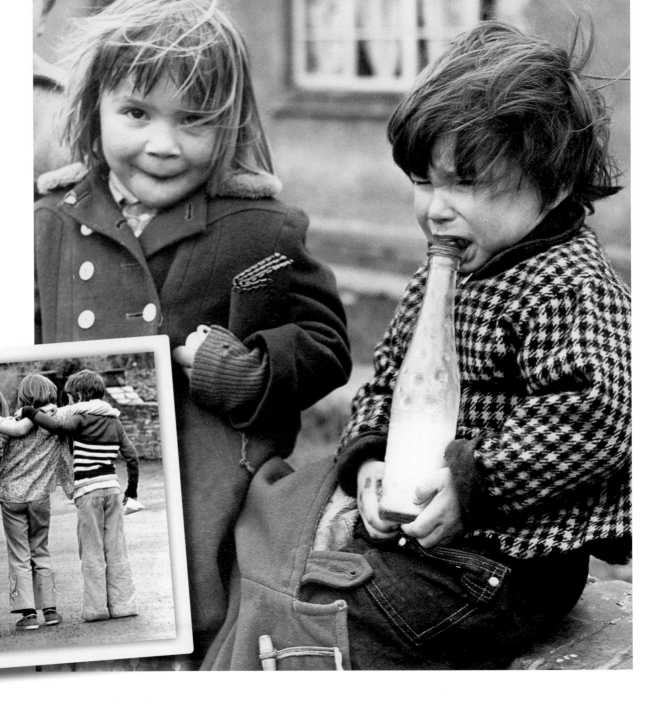

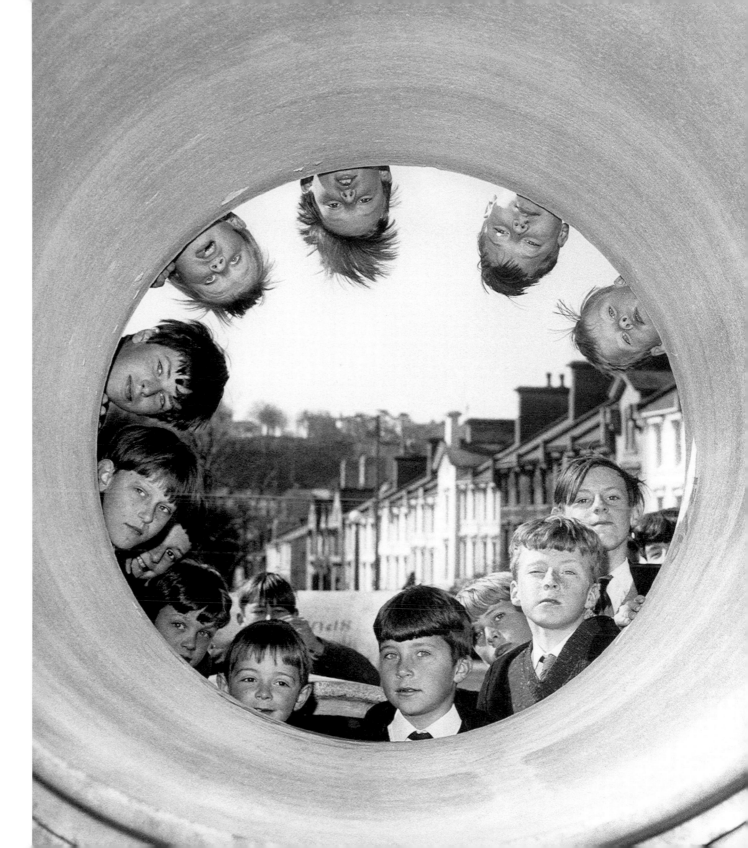

➧ Some Black
Country boys get an
upside-down view
of the world through
sewer pipes in 1966.

◄ Clowning about and making granny laugh, 1970s.

► These two youngsters and their horse are seen passing a high-rise block of flats which had recently been built in West Bromwich in the 1960s.

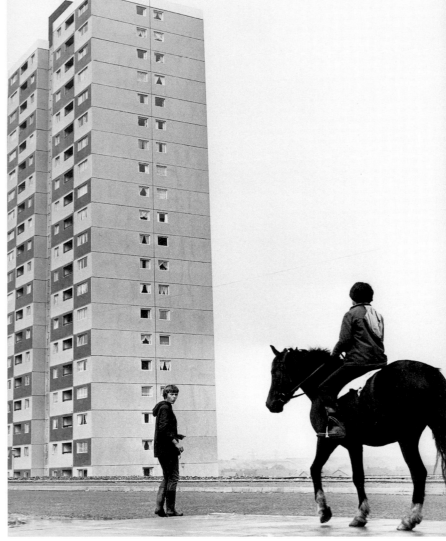

◆ Will you be my Valentine? Four-year-old Maria Chapman goes for the younger boys as she attempts to kiss two-year-old David Wride. Sadly for her, he seems none too interested. This made a great Valentine's Day picture and they were two lovely children.

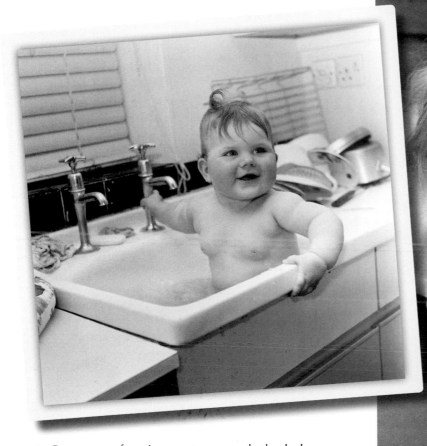

▲ One way of saving water – wash the baby in the sink.

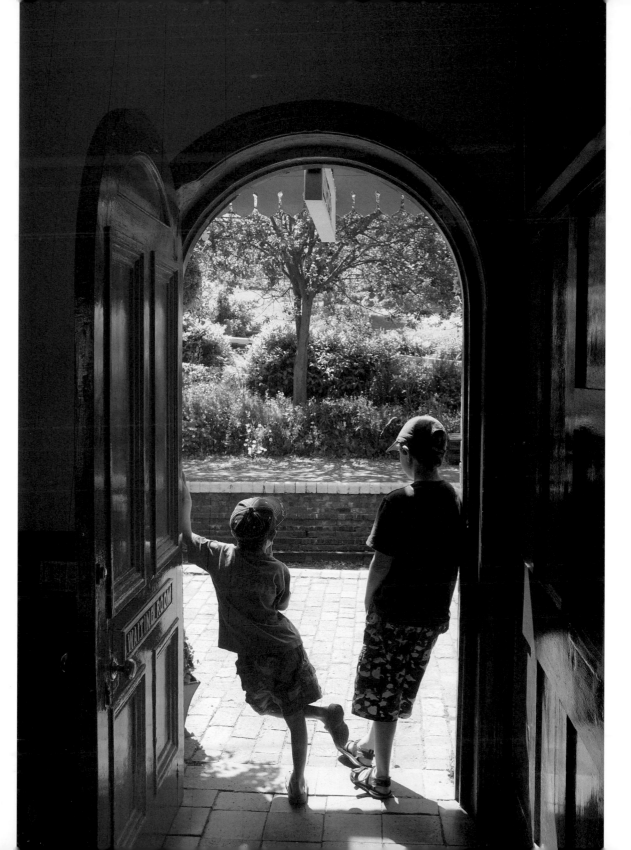

◆ Two young lads leaning on the door of the waiting room at Arley station on the Severn Valley Railway.

CHAPTER 6

FACES AND PLACES

This chapter is a miscellany of pictures taken over the years with some unusual characters and events. We'll encounter a man climbing Ben Nevis at the age of eighty-nine, strip shows for old age pensioners, a mayor sweeping the streets and a jazz musician living in a museum. These and many other images are all part of the rich tapestry of Black Country life and its people, whom I have been fortunate enough to capture on film.

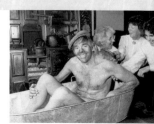

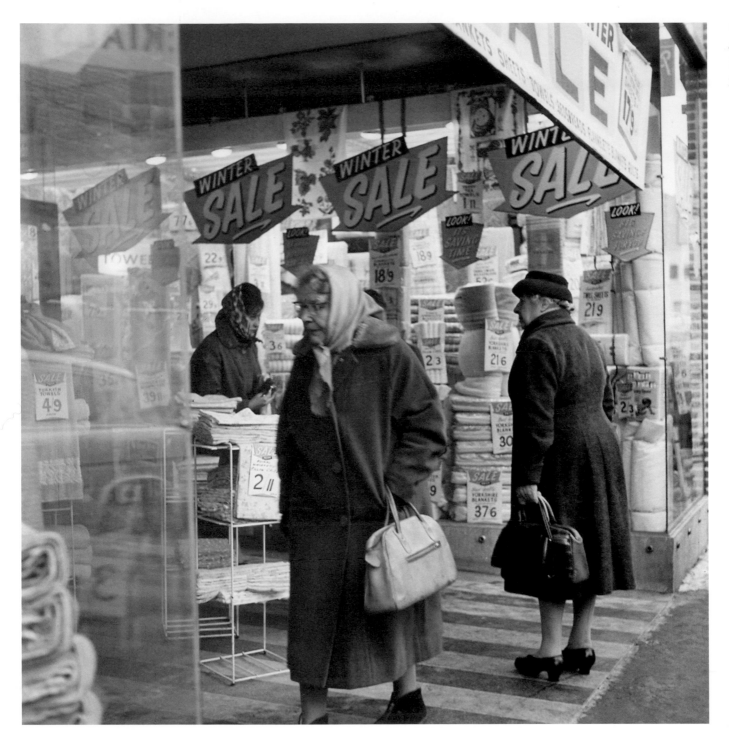

◀ A winter sale on a cold January day in Dudley High Street, 1959.

◆ Dudley High Street, again on a cold day in 1959.

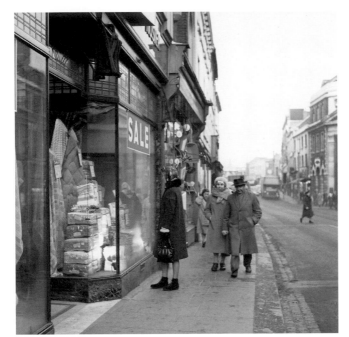

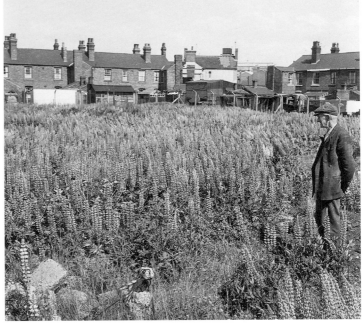

◆ This amazing display of lupins appeared on wasteland in Netherton in 1961.

◆ New homes facing a rubbish dump and with horses running wild, Tipton, 1965.

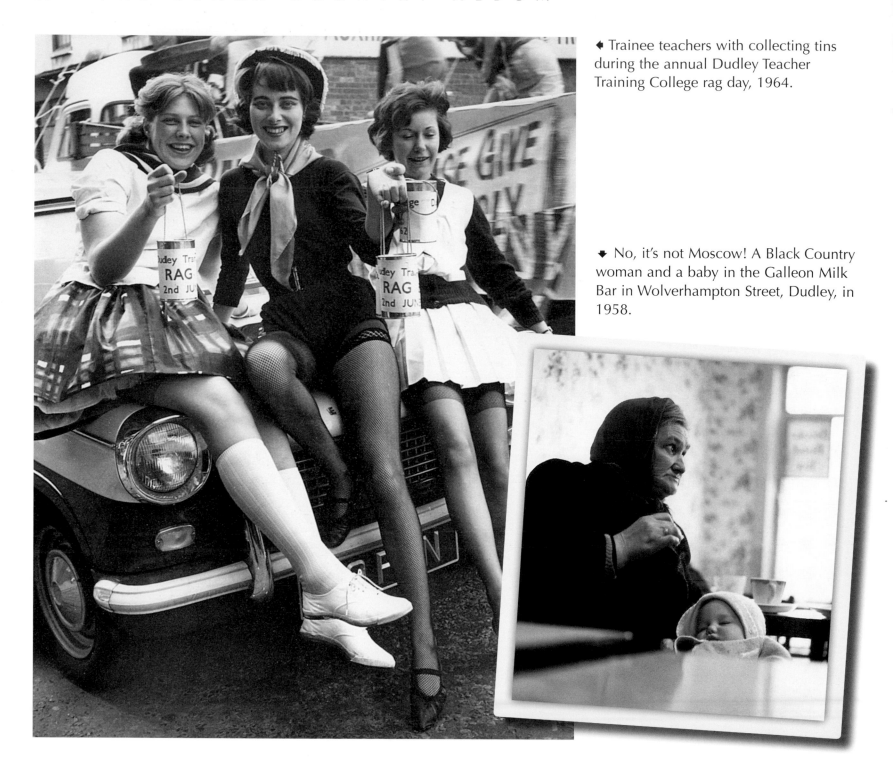

✦ Trainee teachers with collecting tins during the annual Dudley Teacher Training College rag day, 1964.

✦ No, it's not Moscow! A Black Country woman and a baby in the Galleon Milk Bar in Wolverhampton Street, Dudley, in 1958.

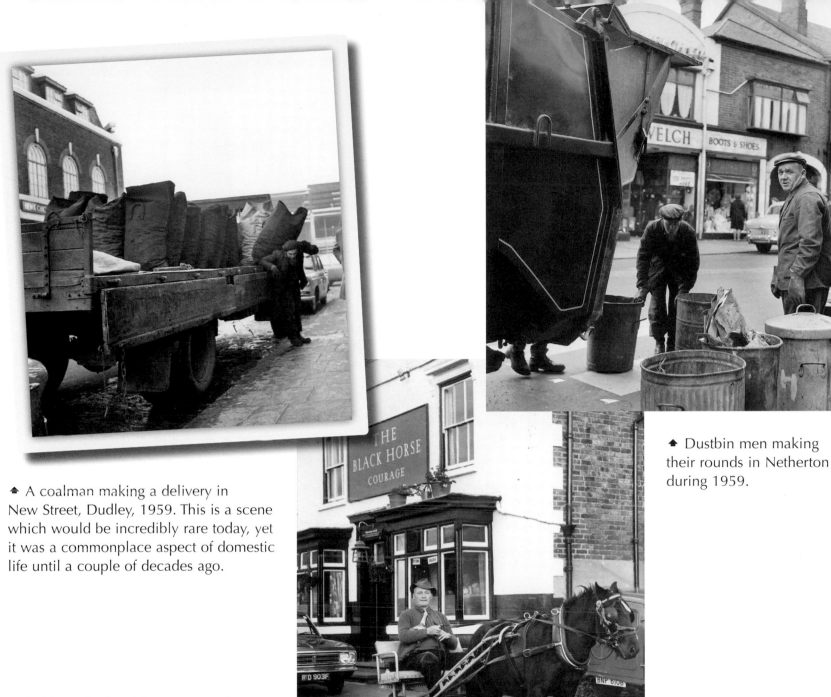

↟ A coalman making a delivery in New Street, Dudley, 1959. This is a scene which would be incredibly rare today, yet it was a commonplace aspect of domestic life until a couple of decades ago.

↟ Dustbin men making their rounds in Netherton during 1959.

◆ A ride to the local in a pony and trap on a Sunday morning in 1968. This shot was taken outside the Black Horse, The Delph, Brierley Hill.

◆ A black and white weigh bridge with a trolleybus beside it, peeping out into Priory Street, Dudley, 1957.

◆ Christmas dinner cooking in the gas oven, 1955. On top, on the gas ring, is the Christmas pudding steaming away, while in the oven is chicken, pork and roast potatoes, but no turkey? Turkey was not an automatic choice for a festive meal in the 1950s.

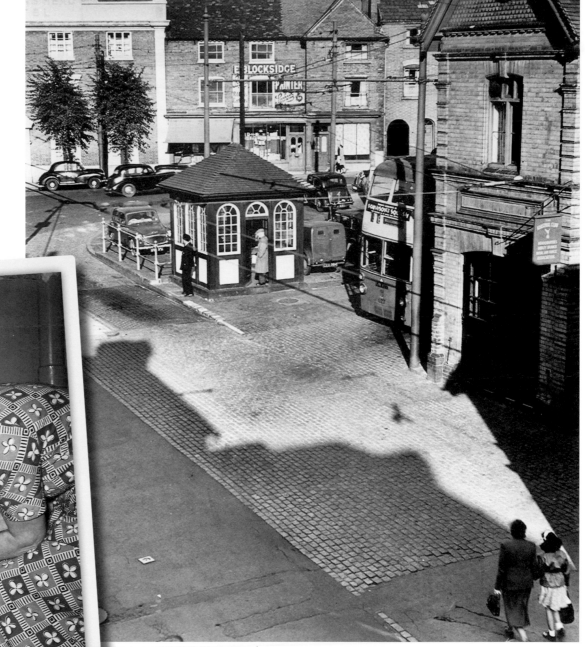

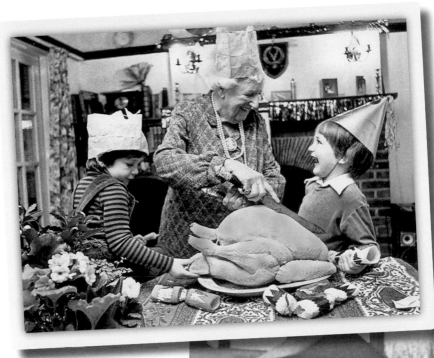

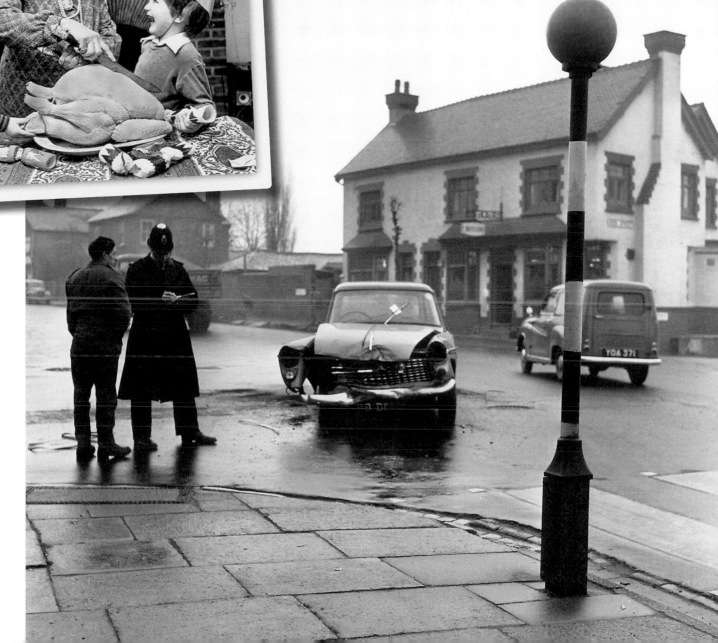

✦ Great-grandma's tales of Victorian times (she was born in 1878) delight youngsters Ross and Philip McKenzie. Mrs May Richards, aged 102 of Kingswinford, is seen here with her great-grandchildren at Christmas 1980.

➦ An old-fashioned copper with a notebook takes down a driver's details after a crash at Coseley in 1963.

◀ Three teenagers on the loose in Kates Hill, Dudley, in 1958.

◆ A teddy boy with blue suede shoes and a pencil-thin tie looks ready to hit the town.

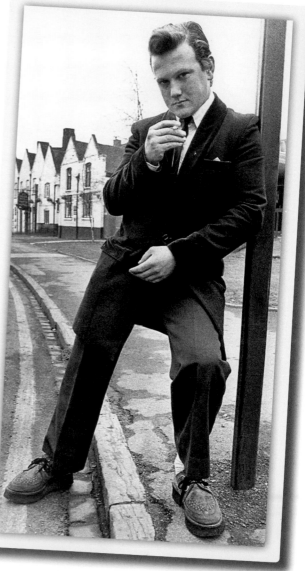

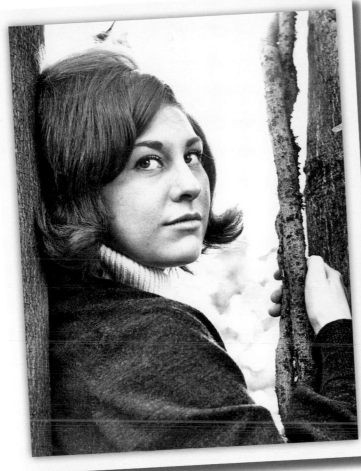

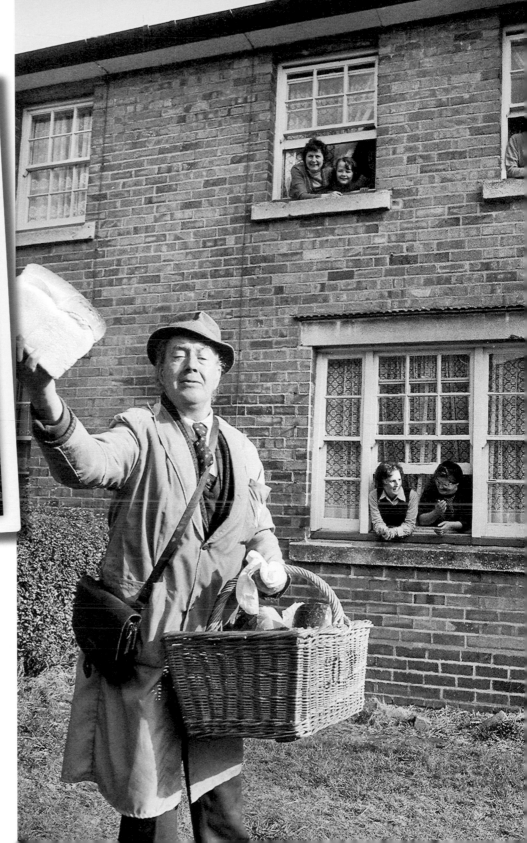

♠ An attractive look from the 1960s – Mary modelled for me and she appeared in many of my pictures as she photographed so well. In 1966 we got married.

♦ The Black Country's very own singing breadman, Jack Day, had been keeping housewives smiling while he delivered their daily loaf for thirty-three years in the 1970s. He is pictured here serenading customers in Glen Road, Upper Gornal.

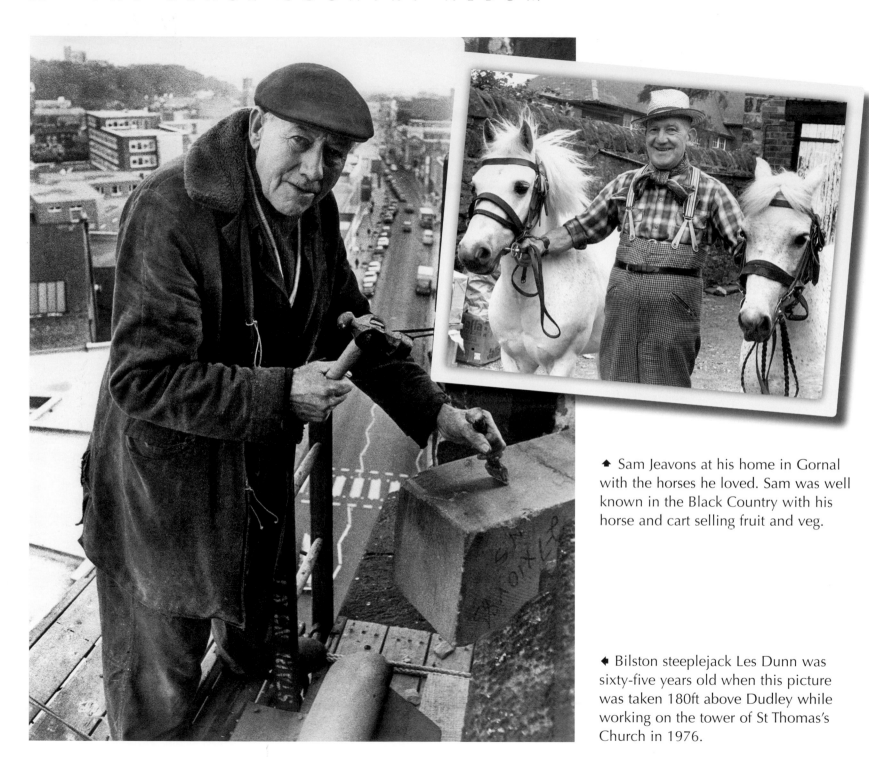

✦ Sam Jeavons at his home in Gornal with the horses he loved. Sam was well known in the Black Country with his horse and cart selling fruit and veg.

✦ Bilston steeplejack Les Dunn was sixty-five years old when this picture was taken 180ft above Dudley while working on the tower of St Thomas's Church in 1976.

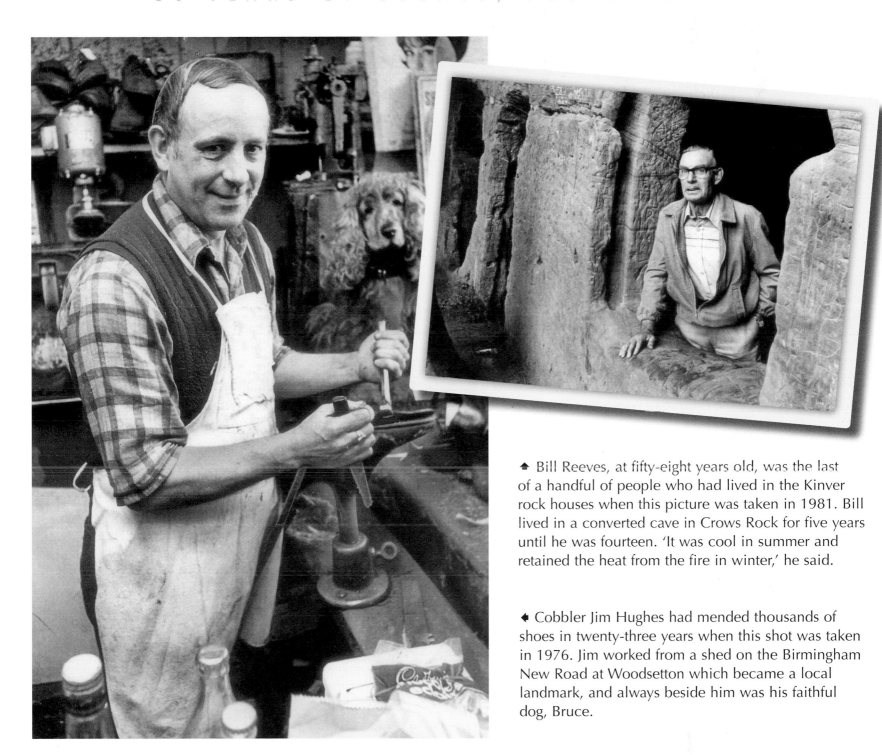

▲ Bill Reeves, at fifty-eight years old, was the last of a handful of people who had lived in the Kinver rock houses when this picture was taken in 1981. Bill lived in a converted cave in Crows Rock for five years until he was fourteen. 'It was cool in summer and retained the heat from the fire in winter,' he said.

◀ Cobbler Jim Hughes had mended thousands of shoes in twenty-three years when this shot was taken in 1976. Jim worked from a shed on the Birmingham New Road at Woodsetton which became a local landmark, and always beside him was his faithful dog, Bruce.

◆ Black Country fishmonger Ron O'Brian hooks a monster buy. This 11ft and 4cwt nurse shark was caught off the Faroe Islands in the 1970s, and was the largest ever sold at Birmingham Fish Market at that time. Mr O'Brian from Dudley, sold the steaks for 25p a pound.

◆ The last blacksmith in the village of Enville, Bob Abbiss, is seen here working at his forge and is watched by his children Robbie, Richard and Timothy.

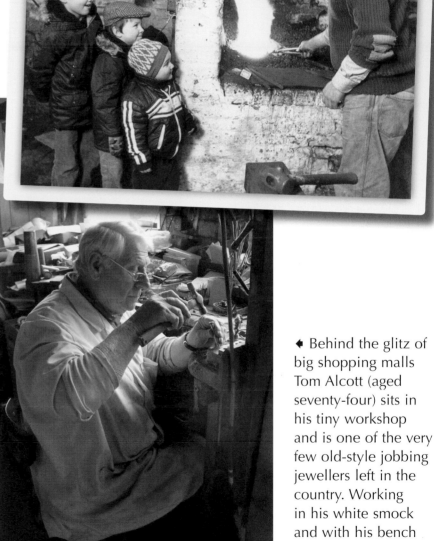

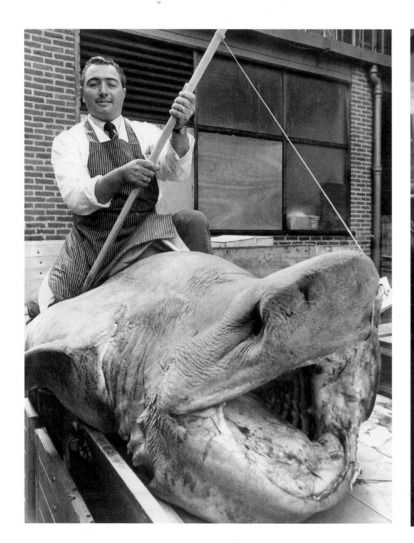

◆ Behind the glitz of big shopping malls Tom Alcott (aged seventy-four) sits in his tiny workshop and is one of the very few old-style jobbing jewellers left in the country. Working in his white smock and with his bench covered in tools, he cuts a distinctly old-fashioned figure.

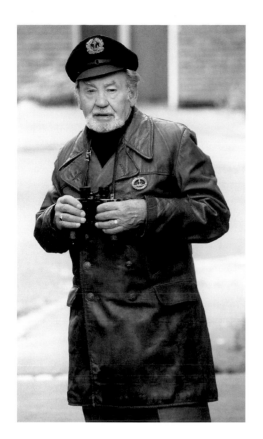

◆ Former U-boat crewman Karl Falk is seen here wearing his Second World War German naval uniform. After being taken prisoner by the Royal Navy he settled in the Black Country and became a tireless worker for the RNLI. In 1981 he collected hundreds of pounds for the Penlee lifeboat disaster fund, and travelled to Cornwall to personally hand over the cash he'd raised.

◆ Bert Bissell, Dudley's first full-time probation officer, looks out of his garden shed in 1958. The shed, amazingly, served as Dudley's first probation office for many years.

◆ The old man and the mountain. Bert Bissell starts his ascent of Ben Nevis in 1991 at the age of eighty-nine and this was the last time he made it to the summit. Bert died at the age of ninety-six and during his lifetime had been a peace campaigner and an avid mountain climber. In 1945 he led a party of young people to the summit of Ben Nevis on VJ Day and constructed a peace cairn. He repeated this trip annually for more than fifty years with members of Vicar Street Young Men's Bible Class, Dudley. I knew Bert for many years and he was a sincere, kind man who never had a bad word to say about anyone – a rare breed.

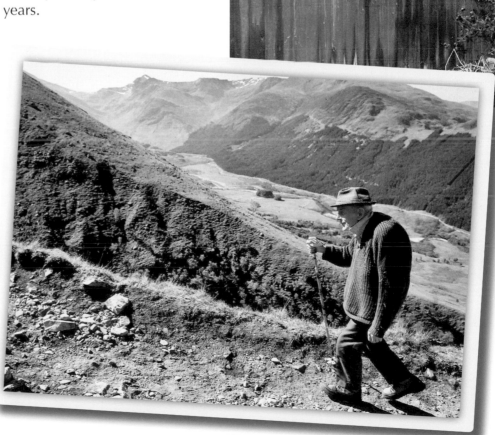

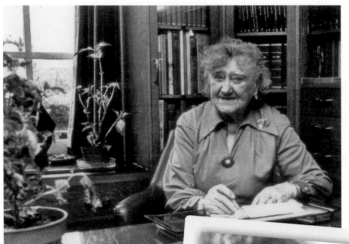

◆ Getting into the record books was Mary Moody, as the oldest company chairman in the world. At the age of 100 in 1980 she was the boss of Mark & Moody of Stourbridge.

◆ In 1982 Dudley's new mayor, Cllr Bob Griffiths, launched a clean-up campaign and took to the streets himself to spruce up Dudley Market Place in his mayoral robes. Bob, who was a great character, got into hot water for using the robes for a non-official occasion.

◆ The first female roadsweepers in the West Midlands were these two Black Country girls, Anne Bowater and Christine Morris.

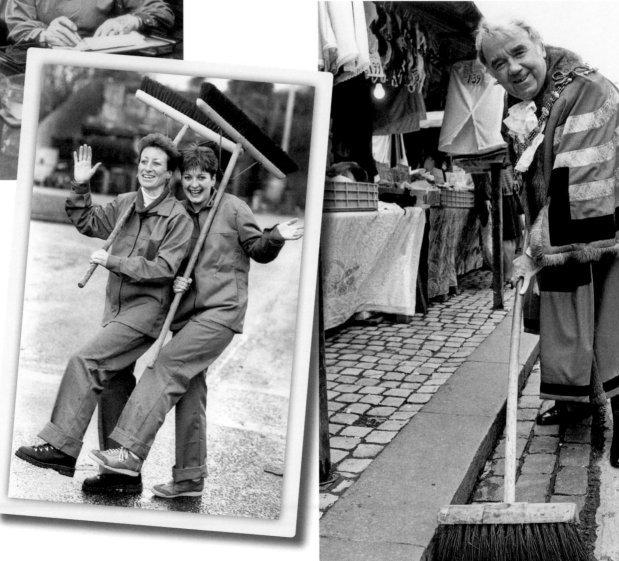

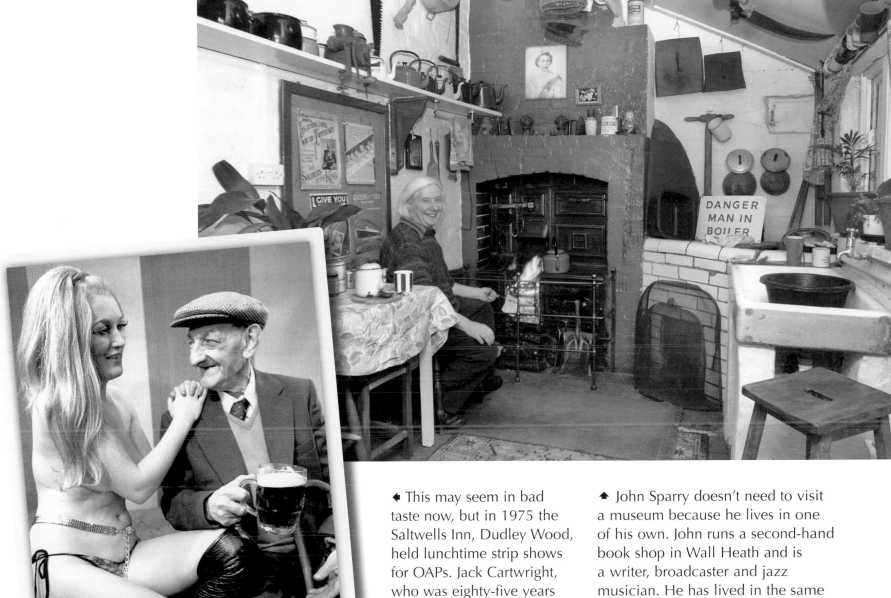

◆ This may seem in bad taste now, but in 1975 the Saltwells Inn, Dudley Wood, held lunchtime strip shows for OAPs. Jack Cartwright, who was eighty-five years old at the time, is seen here enjoying a drink with stripper Anastasia.

◆ John Sparry doesn't need to visit a museum because he lives in one of his own. John runs a second-hand book shop in Wall Heath and is a writer, broadcaster and jazz musician. He has lived in the same house for more than fifty years with no bathroom or outside toilet and an old-fashioned boiler. He has no washing machine, TV or car, but he is a happy man living in a time warp.

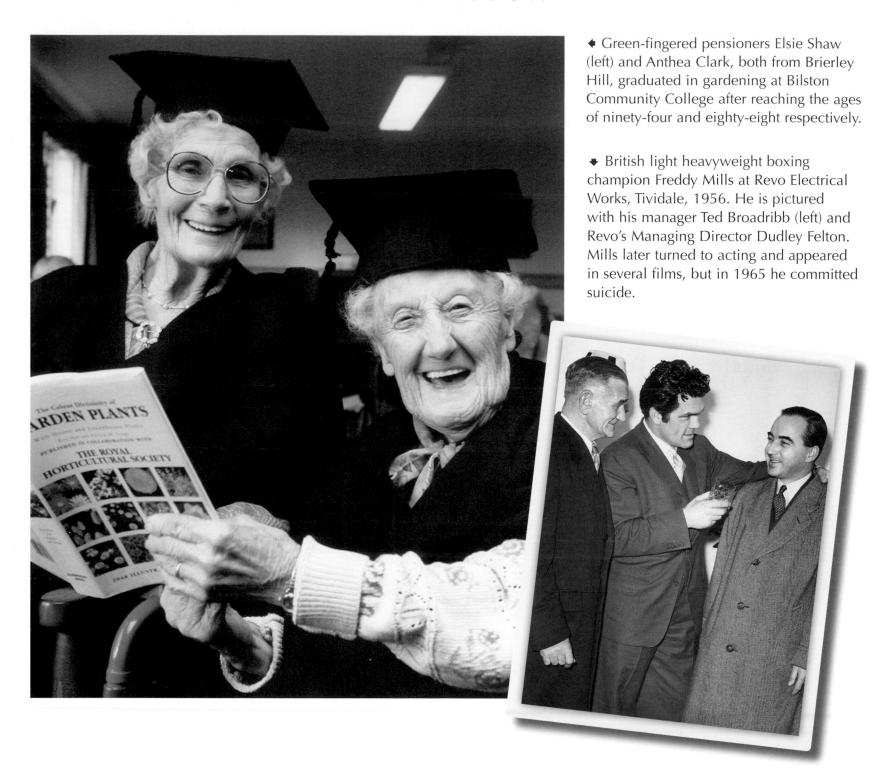

◆ Green-fingered pensioners Elsie Shaw (left) and Anthea Clark, both from Brierley Hill, graduated in gardening at Bilston Community College after reaching the ages of ninety-four and eighty-eight respectively.

◆ British light heavyweight boxing champion Freddy Mills at Revo Electrical Works, Tividale, 1956. He is pictured with his manager Ted Broadribb (left) and Revo's Managing Director Dudley Felton. Mills later turned to acting and appeared in several films, but in 1965 he committed suicide.

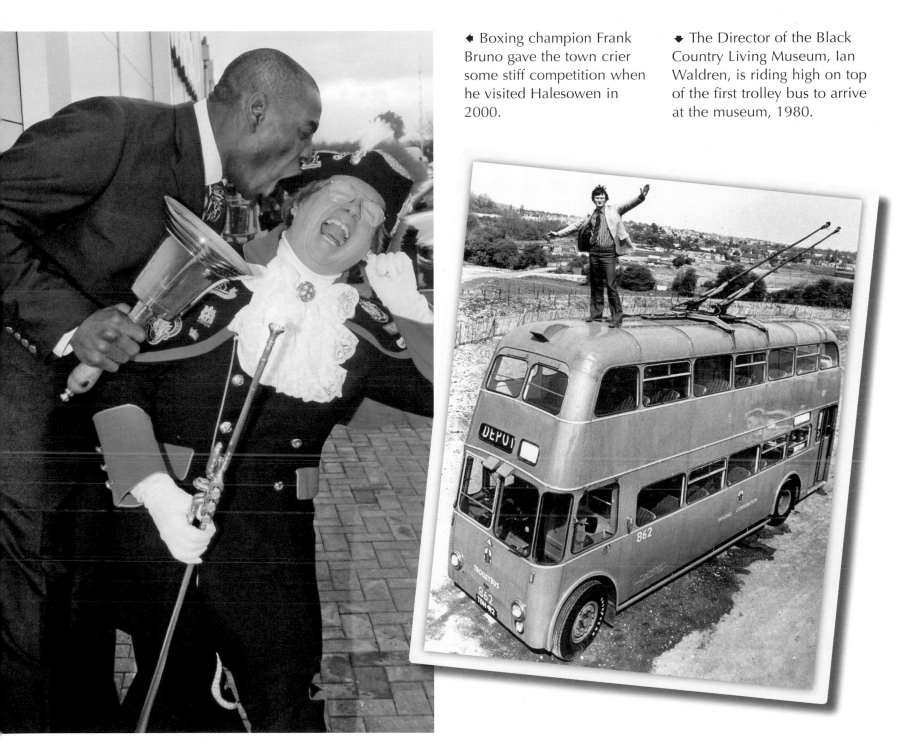

◆ Boxing champion Frank Bruno gave the town crier some stiff competition when he visited Halesowen in 2000.

◆ The Director of the Black Country Living Museum, Ian Waldren, is riding high on top of the first trolley bus to arrive at the museum, 1980.

◆ Alan Gorrod and John Bailey were busy reconstructing a Victorian closet at the Black Country Living Museum in 1998, when John was taken short!

◆ Black Country Living Museum guides Amanda Nash and Bob Dale hang onto the anchor chain made for the *Titanic* in Netherton. They are seen in front of the Rolf Street Baths which once stood in Smethwick and dates from 1888, but was later taken down and rebuilt brick by brick at the museum.

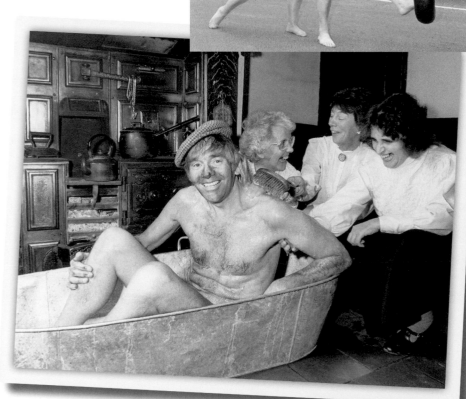

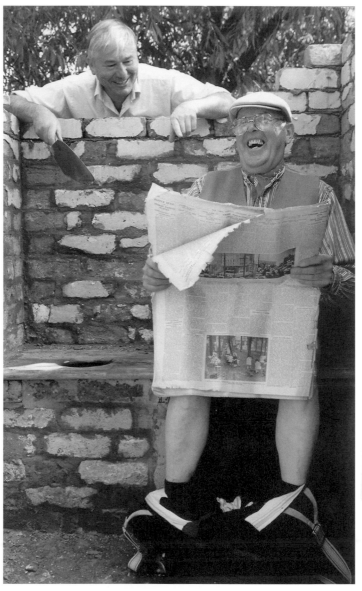

◆ Alan Carter has some bathtime fun at the Black Country Living Museum when friends of the museum staged their annual weekend live-in.

◆ Bobbies on bicycles always make good pictures and none were better than this one. It was taken in Dudley to promote the National Cycle Festival in 1987 and later used to publicise a national photographic competition.

◆ Peter Rawlinson eating worms to raise money for Dudley Rag in 1980. I can confirm that he did actually eat them!

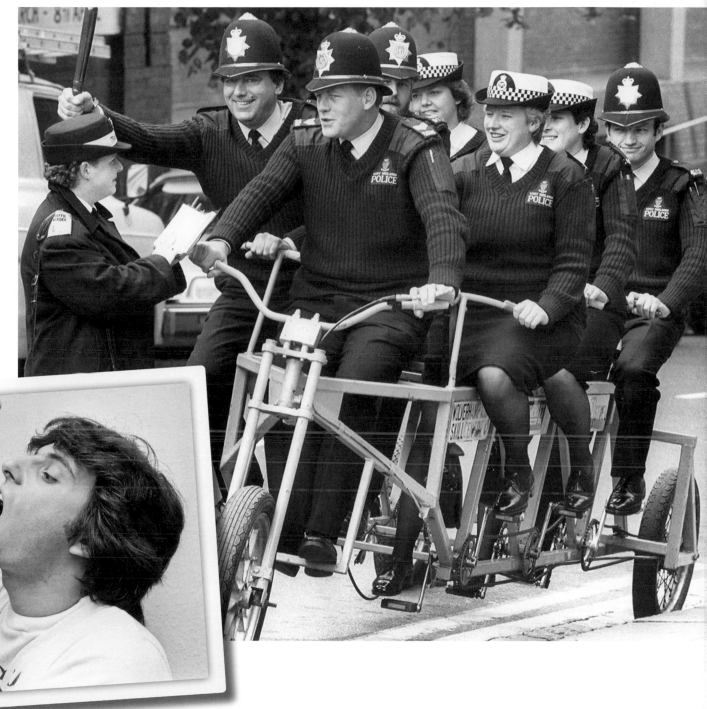

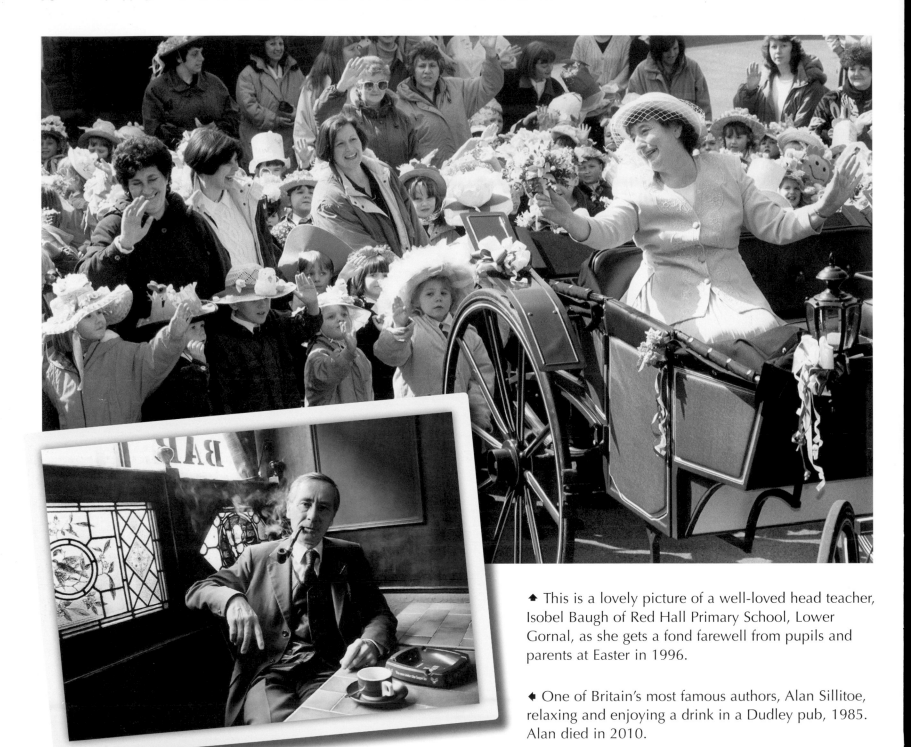

♠ This is a lovely picture of a well-loved head teacher, Isobel Baugh of Red Hall Primary School, Lower Gornal, as she gets a fond farewell from pupils and parents at Easter in 1996.

♠ One of Britain's most famous authors, Alan Sillitoe, relaxing and enjoying a drink in a Dudley pub, 1985. Alan died in 2010.